THE DENVER BEAT SCENE

THE MILE-HIGH LEGACY OF KEROUAC, CASSADY & GINSBERG

ZACK KOPP

Published by The History Press
Charleston, SC 29403
www.historypress.net

Copyright © 2015 by Zack Kopp
All rights reserved

First published 2015

Manufactured in the United States

ISBN 978.1.62619.779.4

Library of Congress Control Number: 2014954499

Notice: The information in this book is true and complete to the best of our knowledge. It is offered without guarantee on the part of the author or The History Press. The author and The History Press disclaim all liability in connection with the use of this book.

All rights reserved. No part of this book may be reproduced or transmitted in any form whatsoever without prior written permission from the publisher except in the case of brief quotations embodied in critical articles and reviews.

In memory of James Stuart LeFevre.

Contents

Acknowledgements	7
Preface	9
Introduction: The Beat Generation	11
The Denver Beat Scene	21
Jack and Neal and Denver	27
Neal and Allen and Denver	35
Neal's Youth in Denver	39
Jack and Ed White and Denver	47
Lu Anne Henderson	49
Carolyn Cassady (née Robinson)	52
Denver Jazz Scene, 1940s	55
Al and Helen Hinkle	64
Justin W. Brierly	67
Jack's House in Lakewood and Denargo Market	72
Neal Cassady as Countercultural Icon	75
Denver Beats in the '60s and '70s	80
Billy Burroughs and Ed Ward	86
Bloodlines	91
The Hyatts	96
The Johnsons at Naropa	106
Neal Cassady: The Denver Years	117
All About Angles	127

Contents

Appendix: Beat Tour Stops In and Around Denver	135
Index	141
About the Author	144

Acknowledgements

Heather Dalton for the recommendation; Addison Morris of Rocky Mountain High Tours; Becky LeJeune; Kelly Brun; Travis Combs; Robert Hyatt; Michael Scalisi; C. Phillip Pitman, unforgotten; Sara Tice; Ed and Marcia Ward; Devin Scheimberg; Daniel Scheimberg; Cathy Cassady Sylvia/the Cassady estate; Susan M. Squibb; Wendy Woo; Nathan Lockrem; Naropa University; Charles Snyder; Mark Bliesener; Tommy Kaui Nahulu; Lisa A. Flowers; Taylor Grant; Mari Christie; Vermont College of Fine Arts; Mutiny Information Café; and my mom and dad. With love.

Preface

I've lived in Denver for more than thirty years. By the time I moved here in 1983, the city had already changed extremely from the days when Neal Cassady lived here and Jack Kerouac and Allen Ginsberg visited him or came looking for him. This trend has only increased in years since, but multiple landmarks remain, whether overshadowed by the growth of modernity, overlooked in less commercial neighborhoods or active in the expressions of creative artists in the city. The present volume provides an accounting of many relevant spots in Denver and environs related historically and through cultural effect to the Beat Generation. Denver's relationship to the principal Beats and their successors has always been that of a nerve center, a sort of engine room in which to recharge before venturing forth to New York City, San Francisco, Morocco, Haight-Ashbury, Greece and elsewhere.

In accordance with this model, mention is made of Naropa University's Jack Kerouac School of Disembodied Poetics in Boulder, co-founded by Ginsberg and Anne Waldman in 1974, and other outlying areas are made reference to wherever necessary. In the '60s, Denver Beat purists like Tony Scibella and Larry Lake went underground, shunning association with what they perceived to be the showy glad-handing of the hippie love gang becoming popular at the time—while preserving a thriving local scene of publication and performance. Landmarks of these second-wave anti-famous Denver Beats are noted as well, thanks to my connections with the Denver spoken word scene.

Preface

From the standpoint of historical inquiry, this book explores the relationship between Denver's Neal Cassady and the Massachusetts-born author Jack Kerouac, who popularized his friend as the vibrant, captivating antiheroic Dean Moriarty in a book called On the Road, which set into motion culture-changing trends continuing to the present day. Neal's attempt as a young man to win his way into the Columbia University crowd in New York through a Denver connection, his plan being to gain acceptance into that lucrative clique of upcoming writers and learn how to write through that association, resulted in an unexpected explosion of creativity and cultural change in America when he met Jack, who saw him as a brother and a model for himself. As a writer of fantastic biography in the age before "creative nonfiction" was an established genre, Kerouac became official scribe of all his best friends' fates—insofar as *he* perceived them, insomuch as *they* allowed it—with the intent of an authenticity so pure it would subsume even his own authorial bias. He would write from the heart, without changing a word, and do it as fast as he could. This is an unmanageable proposition for most writers, and one currently rarely in evidence among the popular stuff. Said approach might produce an improperly possessive effect in the chronicler. Events and opinions contrary to the author's ideal might be omitted or downplayed or misread. Jack Kerouac's books are an honest recording of their author's idealized perception of his life from day to day, including estimation of his friends, in particular Denver's Neal Cassady, whom he praised and blamed alternately in his visions and dreams. Your reporter lacks experience writing nonfiction outside grad school and several citizen journalism articles and interviews but was profoundly affected by Jack Kerouac's autobiographically based "spontaneous prose" when he discovered it as a teenage aspiring writer. The research I've done for this book has opened up a cornucopia of brand-new perspectives on Neal and Jack's uncomfortable symbiosis as author and subject and the ways that connection misfired or overshot for both men, as well as a thorough accounting of a chapter of Denver's history largely unrecorded. There has never been a book like this before. I hope you like it.

Introduction
THE BEAT GENERATION

The self-named "Beat Generation"—including writers like Jack Kerouac, Allen Ginsberg, Gregory Corso, William S. Burroughs (who never accepted the classification for himself) and many others—was/is an American literary movement that first declared itself under that name on November 16, 1952, with the publication of an article in the *New York Times* called "This Is the Beat Generation." Its author, John Clellon Holmes, who attended Columbia University with Kerouac, characterized members as having "an instinctive individuality, needing no bohemianism or imposed eccentricity to express it. Brought up during the collective bad circumstances of a dreary depression, weaned during the collective uprooting of a global war, they distrust collectivity."

It's hard to say who first coined the phrase. Maybe Holmes himself in the first "Beat novel," *Go*, published in 1952. Perhaps the late Herbert Huncke, Times Square hustler and author, who reportedly first said it to Jack K and possibly heard it from somebody else in Times Square or out riding the rails before the disappearance of America's once vibrant hobo culture. For the purposes of this book, it will be used to connote a willingness to approach social and literary forms in a new way, as their driver not their subject. Regardless of formal variety, the Beats shared a willingness to experiment with established norms of behavior in these two areas.

Contemporary "alt lit" writers like Tao Lin (*Shoplifting from American Apparel*) and Megan Boyle ("Everyone I've Ever Had Sex With") have been compared to the Beats by bloggers for their shared unwillingness to compromise on standard

Introduction

modalities of form. Denver-born writer John Fante's writing displayed a similar seemingly unaffected tone in his 1936 novel, *Ask the Dust*, before he moved to Los Angeles and disappeared into the morass of screenwriting. Prolific author Charles Bukowski, also an Angeleno—although he wrote his stuff long before the Beat Generation's advent as a meme in popular consciousness—would likely never have become as successful as he was, beginning in the 1970s, for lack of their prior example.

While the Beats' explicit, if poetic, writings on taboo subjects may seem quaint by comparison with modern examples, they were among the first writers to popularize the habit after World War II, enabling everything that followed. They were creative iconoclasts who believed in living free of the hang-ups of conventional society. Shared experiences, rather than literary tendencies, united them, and the name was designed to captivate a slogan-happy world. Several key Beat associates, including Ginsberg and Burroughs, were outspokenly gay or bisexual.

It was *San Francisco Chronicle* columnist Herb Caen who came up with the dismissive slur "beatnik" due to the coinciding of *On the Road*'s publication in November 1957 with the Russians' launching of a satellite called Sputnik, linking the Beats with a perceived Cold War Communist threat. The same kind of apparently reflexive opposition by the establishment, which became more and more hysterical—as demonstrated in op ed columns in all the big cities' newspapers—added greatly to the Beats' popularity, even if the popular conception of what the name meant was all wrong. Jack Kerouac's own interpretation of the meaning of the word *Beat*—one akin to the Latin word *beát*, meaning holy, as in the biblical beatitude—is well known. He has also defined it as "low down in the world" and "sympathetic."

Kerouac reportedly felt so transformed and spiritually empowered after an experience of sixty-three days of extreme solitude in the mountains of the Pacific Northwest (as recounted in the beginning of *Desolation Angels*, which was published in 1958) that he showed up at the office of publisher Sterling Lord, apparently drunk, dramatically flinging the "Original Scroll" of *On the Road*—written on a teletype role without any paragraph breaks rather than double-spaced and neatly boxed, per custom—across the room. Lord observed that the manuscript needed editing. Kerouac thought of himself as a born writer with a duty to chronicle his own ever-changing circumstances as artfully as possible. In response, he asserted the text had been dictated by the "Lord God Himself" and ought not to be changed.

When published (with changes) in 1957, *On the Road* made its author an overnight star. Popularity was surely a difficult passage for the author, certainly

Introduction

Painting by Gregory Corso.

a far cry from the "[s]cribbled secret notebooks, and wild typewritten pages, for yr own joy" idealized in his *Essentials of Spontaneous Prose*, written in 1953 to explain his prose technique to Allen Ginsberg and William Burroughs. Fame let Jack Kerouac down. The only reputation he achieved in his lifetime was as a delinquent among true writers. Despite having been, in a sense, a first cause of the growing countercultural trend that sprang from the Beats' popularity, in the end Jack Kerouac sheltered in his conservative roots. He died of internal bleeding induced by heavy drinking at home with his mother and wife in 1969 in College Park, Florida. Since the fall of 2000, the Kerouac Project has been accepting submissions for writers' residencies at the former Kerouac home near Orlando.

The Beat Generation is often accused of having been a "boys' club." Kerouac's near total abandonment of daughter Jan (*Baby Driver, Trainsong*), as recounted in *Use My Name: Jack Kerouac's Forgotten Families* (Jones), and William S. Burroughs's accidental shooting of his wife, Joan Vollmer Burroughs, in a drunken game of William Tell and certain of his writings notwithstanding, there are notable exceptions to this generalization, many of them collected in *Women of the Beat Generation: The Writers, Artists and Muses at the Heart of a Revolution*, edited by Brenda Knight; *The Portable Beat Reader*, edited by

INTRODUCTION

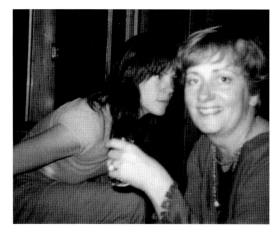

Left: Jan Kerouac and Jane Faigao. *Courtesy of Wendy Woo.*

Below: Lincoln Building (LM). *Courtesy of Naropa Institute.*

Kerouac: A Biography author Ann Charters; and *A Different Beat*, edited by Richard Peabody. All these books tend toward a more balanced view of the movement, gender-wise, than pundits and touts of its era claim.

As a rule, Beat girlfriends, lovers, wives, ex-wives and even female Beat writers are marginalized and under-portrayed in writing produced by the men. In fact, the genesis of this group of creative writers had strong elements of homosexuality, as we've seen, but also included the presences and voices of several strong women, including Diane di Prima (*Memoirs of a Beatnik*), Joyce Johnson (*Minor Characters*), Carolyn Cassady (*Off the Road*) and Anne Waldman (*Fast-Speaking Woman: Chants and Essays* and others).

Introduction

Societal convention was even more biased in favor of men in the 1940s than today; women were deemed crazy for being outspoken or unconventional, and there was an epidemic of commitment of such cases to mental hospitals at the time of the Beat crowd's formation. This is commented on by Gregory Corso in Richard Lerner and Lewis MacAdams's retrospective documentary film, *What Happened to Kerouac?* (2012). Masculine bias notwithstanding, the Beat Generation inspired a trend that has increased the primacy of creative expression by women in the United States in the decades since. It was with poet Anne Waldman that Allen Ginsberg founded the Jack Kerouac School of Disembodied Poetics at Boulder's Naropa Institute (later University) in 1974. New York City punk rock pioneer Patti Smith, who was a close friend of William S. Burroughs, attended Allen Ginsberg's deathbed. Herself a poet, and one of the strongest figures in the emergence of that new musical form in 1974 New York City, recently set Jack Kerouac's poem "The Last Hotel" to music with the help of fellow punk luminaries Thurston Moore and Lenny Kaye.

Amiri Baraka (1934–2014), formerly known as Leroi Jones, is a prominent African American Beat writer. He came into contact with jazz, avant-garde Beat Generation, Black Mountain and new York School poets after moving to the Lower East Side of Manhattan in 1957. Baraka published his first volume of poetry, *Preface to a Twenty-Volume Suicide Note*, as Jones, in 1961. (Diane Di Prima co-edited the literary magazine *The Floating Bear* with Amiri Baraka from 1961 to 1969 and was a major player in the transition from Beats to Hippies through her involvement with the Diggers in San Francisco's Haight-Ashbury district.)

Other non-Caucasian Beats include Bob Kaufman, who was African American, and "Brown Buffalo" Oscar Zeta Acosta, later to be immortalized as Hunter S. Thompson's "lawyer" in his *Fear and Loathing in Las Vegas*.

Thompson died of a self-inflicted gunshot wound on February 20, 2005 (while sitting at the typer, which reportedly had the word "counselor" at the center of the page). Family members reported to the press at the time their belief that his suicide was a "well-thought-out act resulting from his many painful medical conditions." Said longtime Thompson illustrator Ralph Steadman, "He told me 25 years ago that he would feel real trapped if he didn't know that he could commit suicide at any moment." The deed may also have been, in some part, a reaction to Bush II's ongoing campaign against privacy and human rights in general; Thompson's novel *Kingdom of Fear* (2003) showed him to be thoroughly disgusted with the state of affairs

Introduction

politically after the September 2001 attacks. Jann Wenner argued in *Gonzo* that Hunter's suicide seems contraindicated in light of the good he might have done opposing such an encroachment. Alive or dead, I'm grateful for the trail he blazed, along with investigative satirist Paul Krassner and other "Gonzo" journalists. This groundbreaking journalistic style (at the time) can be seen as having developed from the Beats' popularization of individualistic written expression.

Subsequent to the Beats' heyday, in the 1960s there was an outpouring of creative expression from citizens all over the world who found society's sanctions of behavior repressive, the spectrum of acceptable options far too narrow: men were to work hard and provide for their families, and women were to bear and raise the men's children. In a very real sense, this program seemed made for automatons and worker drones, and in the United States, the publication of *On the Road* was part of the same trend as the popularity of Elvis Presley's music and films like *Rebel Without a Cause*—moving toward an independence of spirit that was considered rebellious by the old guard, who considered it a "Beat insurrection…Beat mutiny…terms I never used," as Kerouac himself lamented on arch-conservative William F. Buckley's *Firing Line* program in 1968.

The writers' exploits ranged the world, from New York City to Burroughs's flat in Tangier, Morocco, to the "Beat Hotel" in Paris—where youngest inner-circle Beat Gregory Corso stayed with poet Harold Norse, William S. Burroughs and others—to Jack Kerouac's hometown of Lowell, Massachusetts, to the Florida town in which he died to City Lights Books founder and publisher Lawrence Ferlinghetti's cabin in Big Sur, California, to North Beach farther down the coast.

No matter how far they rambled, most of the early Beat writers seemed to have been profoundly affected in one way or another by a man from Denver named Neal Leon Cassady (1926–1968), who came from the West seeking knowledge only to thrill and inspire the Columbia crowd with his untutored zest in the winter of 1946—a Nietzschean superman suddenly there in their midst, dashing around in a tweed sport coat getting everyone drinks and ashtrays, the guest playing the host. It may have seemed notable to the Columbia students that anyone would behave spontaneously at all in such a conditioned atmosphere, let alone in such a generous manner. The voice that Neal used in postal correspondence also struck Jack Kerouac as especially free and unfettered and capable in comparison to the lofty art he made of writing at the time of their sending. One letter in particular, concerning *coitus interruptus* (Neal hiding in the bushes to evade a strict parent)

INTRODUCTION

Art from *Neal Cassady: The Denver Years. Courtesy of Daniel Crosier and Karl Christian Krumpholz.*

Introduction

and delayed life-changing consequences, he found of especial interest. He was quoted in issue 43 of the *Paris Review* saying the letter had disappeared:

> *It was the greatest piece of writing I ever saw, better'n anybody in America, or at least enough to make Melville, Twain, Dreiser, Wolfe, I dunno who, spin in their graves. Allen Ginsberg asked me to lend him this vast letter so he could read it. He read it, then loaned it to a guy called Ged Stern who lived on a houseboat in Sausalito, California, in 1955, and this fellow lost the letter: overboard I presume.*

The letter—referred to as the "Joan Anderson letter" for convenience by the various Beats as they passed it around—is published, in part, along with several other exceptional missives, in *Neal's Collected Letters, 1944–1967* (edited by Dave Moore), a volume giving ample evidence of Neal's innate skill with a pen when he wasn't *trying to write well*. Neal Cassady's particular genius was trusting himself at certain things—stealing cars, wooing girls and so on without "getting hung-up"—inspiring and amazing onlookers with his miraculous success as a result of that faith. By comparison with the freewheeling tone of Neal's letters, his writing in *The First Third* seems contrived and self-aware.

Jack Kerouac (1922–1969) wrote several versions of his most famous book, *On the Road*, the action of which concerned his season of cross-country road trips in the company of Cassady, who, fictionalized as Denver car thief and aspiring writer Dean Moriarty, symbolized the same causeless rebellion as actor James Byron Dean and Sherlock Holmes's alter ego to the establishment. Neal's influence drew many to Denver, with ongoing effects on the city's character. Due in part to him, Denver became a way station for 1960s dropouts heading to LA, some of whom stayed and set down roots that bore fruit in the spoken word scene. Multiple landmarks significant to Neal's life—mentioned in his writings and the writings of those who followed this "sideburned hero of the snowy west" to Denver, including Kerouac and Ginsberg—still stand throughout the Mile-High City and other parts of Colorado. Bruce Cook, in his 1971 book *The Beat Generation: The Tumultuous '50s Movement and Its Impact on Today*, noted:

> *Neal Cassady is, in effect, responsible for the creative impulse that we know still by the name "Beat." Just how important he was to Jack Kerouac and the writing of* On the Road *is perhaps not sufficiently appreciated. Not only was he the model for that novel's central character—the electric,*

Introduction

> *charging and dynamic Moriarty—but Cassady's wild adventures with Kerouac, as they rampaged from one end of the country to the other, also provided the book with all in the way of plot and incident it has.*

Beat history appears in several forms of media, including movies. *Heart Beat* is a filmic adaptation of Neal's wife Carolyn Cassady's experience, starring Sissy Spacek as Carolyn, Nick Nolte as Neal and John Heard as Kerouac and was released in 1980 to mixed reviews. Carolyn is said to have resented the creative license taken by director John Byrum. There have been a number of recent films, among them *Beat* (2000), starring Kiefer Sutherland and Courtney Love; *Big Sur*, starring Jeanne-Marc Barr and Josh Lucas; and *On the Road* (2012), directed by Walter Salles and starring Kristen Stewart and Garrett Hedlund. Many scenes in the latter were set in Denver, but the shooting took place in Montreal, Quebec. David Cronenberg's surrealistic film of William Burroughs's novel *Naked Lunch* (1991) deserves a mention. *Kill Your Darlings* (2013) is a film starring Daniel Radcliffe and Dane DeHaan and focuses on Kerouac and Ginsberg's involvement in events surrounding fellow Columbia student Lucien Carr's slaying of David Kammerer in 1944. Much footage from Neal's later years driving the Merry Pranksters' acid bus appeared in 2011's *The Magic Trip*, assembled by Alison Elwood and Alex Gabney, with retrospective commentary by some of the original players.

The Denver Beat Scene

If Neal Cassady may be considered the midwife of the Beat Generation, his hometown of Denver may be respectfully regarded as the medical college that trained him and one of the rooms of that baby's delivery. Once Neal left Denver in 1947, he never returned beyond brief visits to his dad, Neal Sr., and his stepbrothers, Jack and Ralph Daly, but the genes are still jumping. I was privileged to attend a reading by Neal's granddaughter, Vera Elizabeth Hyatt, at one of Ed Ward's "Stories Stories" events at the Mercury Café not long ago. A young man at another table, spitting image of the young Neal (at first I thought coincidentally), turned out later to have been her brother, Neal's "illegitimate" lookalike grandson, Henry Hyatt. A few weeks later, Denver poet and storyteller Ed Ward hipped me to Denver Beat happenings in the '60s, '70s, '80s and '90s.

Many books have been written about the movement's principals over the years, but much of the Beat movement's history remains undocumented, including a strong and ongoing connection to Denver's spoken word and alternative culture scenes, as documented in this volume. Colfax Avenue—the longest continuous stretch of roadway in the United States and a segment of Route 66 long known for its plentiful bars, bums and loose women—runs straight through Denver, featuring landmarks like Neal's alma mater, East High School (he never graduated and "never finished a single class there," according to late wife, Carolyn, but was honored with a posthumous degree in 2012 after Denver Beat historian Mark Bliesener contacted East High historian Dick Nelson and literature teachers Mark

The Denver Beat Scene

Robert Frazer's class. *Courtesy of Naropa University.*

Ajluni and Michael Hernandez); Pete's Kitchen on Colfax and Race, which has been in operation since 1942; and the former spot of Neal's teenage coffeehouse, the Oasis, at approximately Colfax and Williams.

Of Kerouac's works, both *On the Road* and *Visions of Cody* touch extensively on Jack's time in Denver, both with and without Neal, and through these accounts others, including well-known writers, were drawn to this part of the country. *On the Road*, first published in 1957, was written in a style inspired by Neal's uncommonly fluid, fast and spontaneous manner. Ginsberg's breakthrough book of verse *Howl* is dedicated to "N.C. secret hero of these poems" and features many references to Neal throughout, as in these lines from his poem "The Green Automobile": "Denver! Denver! we'll return roaring across the City & County Building lawn which catches the pure emerald flame streaming in the wake of our auto." February 4, 2011, was nomiated as "Neal Cassady Day" by Denver mayor Guillermo Vidal.

The Beat Generation was a rootless gang of many origins whose writing spoke of an urge to "Go!" at top speed. None of the principals—not even Neal, who came to manhood here—was born in Denver, but multiple landmarks significant to the life of our conflicted hero and mentioned in the writings of those who sought his roots still stand throughout this city and its environs. Other manifestations include the Central City Opera, memorialized by Kerouac in *On the Road*, and Naropa University's Jack Kerouac School of Disembodied Poetics in Boulder, co-founded by Allen Ginsberg and Anne

Right: Charlie Brown's Bar & Grill. *Photo by Michael Scalisi.*

Below: Charlie Brown's Bar interior. *Photo by Michael Scalisi.*

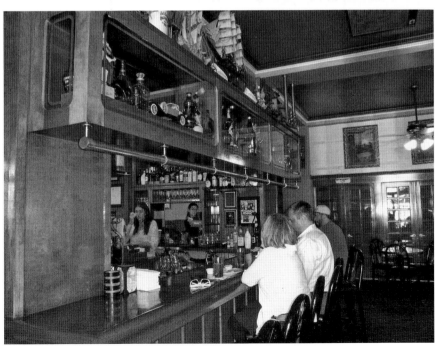

Waldman. Boulder also features the Beat Book Store. William "Billy" S. Burroughs Jr. lived in an apartment on Colorado Boulevard in Denver—"a trashy rooming house," according to Burroughs Sr., which has since been razed. Jack bought a house in Lakewood and lived there with his mother and sister very briefly. Carolyn Cassady interrupted an illicit tryst in her room at the Colburn Hotel above Charlie Brown's Bar on 10th and Grant.

By contrast with the active self-promotion of their forebears, seeing themselves as true cultural revolutionaries who had long since perceived society's sham, Denver Beats in the '60s preferred to go unnoticed. "We wanted to stay underground," affirmed Denver writer Edwin Forrest Ward. "We thought of the hippies as children who stayed too long at the party." Apart from Ward's contact with architect Ed White, Columbia University graduate and longtime Kerouac friend, most of the original players were absent from the Denver Beat scene in the '60s excepting special appearances. Their mantle was taken up by writers like Ward, Tony Scibella, Stuart Z. Perkoff, Jimmy Morris and others, each of whom founded a small press and mass-produced affordable chapbooks to be shared around

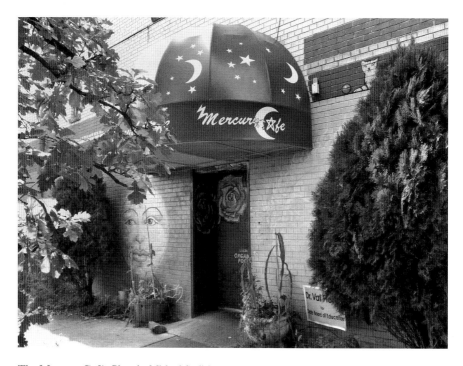

The Mercury Café. *Photo by Michael Scalisi.*

The Mile-High Legacy of Kerouac, Cassady & Ginsberg

the Denver scene. Ward, in particular, has retained an active role in Denver's literary community, hosting decades of weekly open mic poetry readings at the Mercury Café—where I cut my poetry teeth, reading under the pen name "Henry Alarmclock" (I wanted to be a punk poet)—and monthly storytelling sessions.

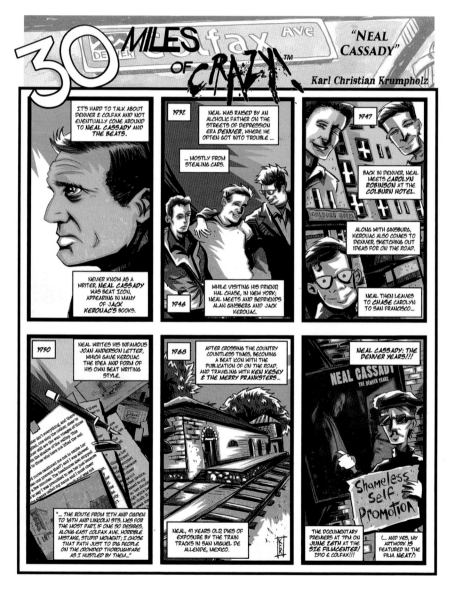

"30 Miles of Crazy: Neal Cassady." *Courtesy of Karl Christian Krumpholz.*

The Denver Beat Scene

A licensed minister of the Temple of Man, Reverend Ward's specialty is weddings. "But the beat goes on," said Ward, whose blog contains a list of Beat 'zines from the '60s, '70s and '80s, including Michael Wojczuk's *New Blood*, Larry Lake's *Mano-Mano* and several of his own. As happened with the legendary 'zine *The Realist* (from Kesey associate and investigative satirist Paul Krassner) and in the subsequent punk 'zine community, mass production took a backseat to quality in the name of expression. Works by Perkoff, Scibella and Morris are available at Amazon, but due to the movement's desire for DIY anonymity, many are special limited-edition copies priced highly due to their limited supply.

In 1994 or '95, Henry Alarmclock was beginning to make a name for himself in the Denver spoken word scene. The people seemed to like my writing, and before long, I started hosting readings myself, sometimes two or three a week. It was easy—all I had to do was volunteer. My alter ego was publicized nationally in a story called "And the Beat Goes On" by Molly Hall; it went out on the UPI wire concerning a slam held in the recently departed Smiley's Laundromat on Colfax at Downing (since closed) highlighting Denver's connection to the Beats. I started to think of myself as a writer, making up phrases like "the golden left hook" (meaning unexpected, sudden tricky endings) and "momentum" (meaning magnetic flow) for qualities I felt were essential to very good writing. But I was no expert.

JACK AND NEAL AND DENVER

Perhaps owing to the death of his older brother, Gerard, when Jack was four years old, Kerouac had a habit of attaching himself to heroic males in a subordinate position in his writing. He did it with Lucien Carr while at Columbia—see his "Old Angel Midnight" (original title "Old Lucien Midnight")—and with Gary Snyder as Japhy Ryder in *The Dharma Bums*. It was in cowboy philosopher Neal Cassady that Jack's tendency to hero worship achieved its extremity: "I can't think of anybody [besides Cody] who knows the sum and substance of what I know…and can therefore on all levels make it all the way with me." Neal himself often referred to Kerouac as "Brother Jackson" and other permutations of this in their correspondence and conversation. In *Visions of Cody*, Kerouac called him "the brother that I lost—that was always laughing on Saturday nights and I haven't seen him since."

From his first fictionalized appearance, as Hart Kennedy in John Clellon Holmes's *Go*, Cassady was characterized as someone full of conversational zing and seemingly possessed of a superhuman ability to manage interpersonal interaction. In *On the Road*, Jack took note of Neal's momentous urgency as a personality driven to constant progress ("because he had no place he could stay in without getting tired of it and because there was nowhere to go but everywhere, keep rolling under the stars"). Neal's prehensile adaptability to social situations both impressed and inspired the shy, socially awkward Kerouac. He admired Neal's seemingly automatic rapport with women, of which he felt himself incapable, except perhaps when in Neal's company.

Cassady's frenetic forward drive came to symbolize the assertive momentum that Jack craved for the "Endless Novel" that he was writing about his life on Earth, starring Jack Duluoz as himself. The name Kerouac finally favored for Neal in this great fictional schema was Cody Pomeray, a character who appears in several of Jack's books, including in *Big Sur* (1962) in the following lines, from which Jack envisions the idealized outcome of his vocation:

> *My work comprises one vast book like Proust's except that my remembrances are written on the run instead of afterwards in a sick bed…chapters in the whole work which I call the Duluoz Legend. In my old age I intend to collect all my work and reinsert my pantheon of uniform names, leave the long shelf full of books there, and die happy. The whole thing forms one enormous comedy, seen through the eyes of poor Ti Jean (me), otherwise known as Jack Duluoz, the world of raging action and folly and also of gentle sweetness seen through the keyhole of his eye.*

Kerouac's portrayal of Lower Downtown Denver was written during his trip there in 1952 as a sort of religious pilgrimage to divine the essence of his chosen subject, Neal/Cody Pomeray—the better to write fiction about him—and should not be regarded as historical record, although it is a record of one man's perception and, to some unquantifiable degree, an eyewitness account as seen through the filter of his own preoccupations. Kerouac used the word "Gaga" to describe Za Za's Barber Shop, formerly located on the lower side of Larimer between 17th and 18th, where Neal Sr. barbered when father and son first came to Larimer Street. In *The First Third*, Neal described Za Za's Barber Shop where he worked as having been "run with an uncommon dignity uncommon to any Skid Row" by the lead barber, whose name was Charley:

> *Over the two decades I had occasion to see him, this dark-faced thin Italian barber, he was never ruffled or out-of-humor; perhaps more surprising, when last seen, not one black hair of his easy-going head had turned, so he still presented the un-aged appearance of the man I first met. Strangely enough, too, the quick-talking Mexican who worked beside Charley for so long also appeared unchanged to me, save for an increased bloat to his always-fat body…while Dad worked on his infrequent morning customers or sat in the battered barber chair to rest his feet, I absorbed what I could of Liberty magazine and the Rocky Mountain News.*

As proof of his unreliability as historic recorder, elsewhere in *Visions of Cody* Kerouac uses the same word, "Gaga," as a name for young Neal's flophouse roommate "Shorty," a legless bum with no teeth who slept in the crook of a pipe and made his spare changing rounds on a roller board. A rare lapse for him.

The men who gathered in rooming houses in the slums of post-Depression America in the 1930s—including places like the Metropolitan on Larimer Street, where Neal and his father stayed—were prompted by different incentives. All of them were broke. Neal Sr. moved in with his son in 1932 following the dissolution of his marriage and the falling off of his barbering customers, along with his sobriety. Young Neal's childhood was spent alternating stays in his mother's apartment at the Snowden on 22nd and Stout Streets, where he was bullied by his older half-brothers, with stays in rooming houses with his father on Larimer Street, then a renowned western skid row full of pool halls and saloons. From *The First Third*:

> *For a time I held a unique position: among the hundreds of isolated creatures who haunted the streets of lower downtown Denver, there was not one as young as myself. Of these dreary men who had committed themselves, each for his own good reason, to the task of finishing their days as pennyless [sic] drunkards, I alone, as the sharer of their way of life, presented a replica of childhood to which their vision could daily turn, and in being thus grafted onto them, I became the unnatural son of a few score beaten men.*

An oft-repeated slogan of Kerouac's—"You've got to legalize the fellaheen" (a word meaning "farmer" or "peasant" in Arab countries like Morocco, where his friend "Old Bull" Burroughs lived)—referred to the apparently inevitable presence of an underclass, necessarily rich in the authentic human experience sorely lacking in the surface appearance of society and the "upper" classes natural to him, as well as an urge to its acceptance. This habitual veneration of society's underdogs would acquire an overtly spiritual tint among the Beats following the discovery of Buddhism by Kerouac, Ginsberg and others. From the moment the New Yorkers met Neal, it was all about mythologizing him. In a Greek myth, Prometheus kidnaps fire from Hephaestus' workshop, smuggles it back to the upper world and gives it to humankind. For Kerouac, Ginsberg and others, Neal Cassady was Promethean in his transference of "joy-mad kicks" from the holy Denver underworld to their collegiate East Coast cloister. English author Chris Challis wrote in *Quest for Kerouac*:

The Denver Beat Scene

> *He is protagonist of both On the Road and Visions of Cody; appears in The Dharma Bums, Desolation Angels, Big Sur, Book of Dreams and Scattered Poems* [by Kerouac]. *He is mentioned in The Subterraneans* [by Kerouac], *and is the "secret hero" of Planet News* [Ginsberg], *is eulogized in The Fall of America* [Ginsberg] *and the subject of songs by the Grateful Dead, the Doobie Brothers, and the engagingly-named Aztec Two Step, among others. After the famous "two sticks" bust he became the "greater driver" for Ken Kesey's Prankster bus, Further. He seems to have possessed exceptional personal magnetism right up to the time of his death.*

Neal Cassady Sr., a kind-hearted man given to immoderate consumption of alcohol and occasional mental lapses, though unable to provide a wealthy position for Neal, appears to have treated him kindly when caring for him. A powerful subtext of *On the Road* is Dean's effort to keep tabs on his wayward father and Sal's joining with him in this effort to track down this ragged patriarch—the father they can't find, the force of whose mythology is strengthened only by his presence through absence in that book and *Visions of Cody*. This scene from *On the Road* details the action of seeking the absent tramp:

> *Neal was very quiet and seemed a little subdued and occupied looking at the old bums in the saloon that reminded him of his father. "I think he's in Denver…this time we must absolutely find him, he may be in County jail, he may be around Larimer Street, but he's to be found. Agreed?" Yes, it was agreed, we were going to do everything we'd never done and had been too silly to do in the past.*

According to Carolyn Cassady, Neal knew where his father was all along, so the search was either invented or misunderstood by author Kerouac. The following bit from *Visions of Cody* details Jack's impression of the storied senior Cassady:

> *On Larimer Street Cody's father was known as The Barber, occasionally working near the Greeley Hotel in a really terrible barbershop that was notable for its great unswept floor of bums' hair, and a shelf sagging under so many bottles of bay rum that you'd think the shop was an oceangoing vessel and the boys had it stocked for a six months siege. Pomeray…tiptoed around a barber chair with scissor and comb, razor and mug to make sure not to stumble, and cut the hairs off blacknecked hoboes who had such vast*

The Mile-High Legacy of Kerouac, Cassady & Ginsberg

Neal Cassady Sr.'s former barbershop. *Photo by Michael Scalisi.*

> *lugubrious personalities that they sometimes sat stiffly at attention for this big event for a whole hour. Cody Sr. was a fine gentleman.*

Known to bums and straights alike as "the Barber," Neal Cassady Sr. is an example of the many thousands of men forced into privation by the financial downturn of the Great Depression. Many of the buildings, formerly flophouses where one or both Neals stayed, still stand north of Lower Downtown Denver and in Five Points, now vacant or converted to places of business—like the St. Elmo Hotel on 17th Street, now the site of a popular restaurant. His lack of financial security, combined with too great a fondness for drink, rendered him an inconstant guardian for his son during their time together. While bearing him no particular grudge, perhaps influenced by boyhood memories of the drunken Neal Sr., who resorted to the alcohol-based fuel "Sterno" or alcohol-based kitchen extracts when nothing else was handy, Neal never became a lush. Neal's parents were married by prominent Denver judge Ben Lindsay. The two are buried at Mount Olivet Cemetery with Maude's first husband, James Daly.

Neal was not only the son of a bum; he was also a child of divorce who spent half his time on a lower-middle-class kick looking in with bum's eyes. When staying at his mother's apartment at the Snowden in a slightly better

neighborhood, Neal underwent regular torments by his half-brothers Jimmy, Jack and Ralph Daly, on the order of forced confinement in an antique folding bed:

> [H]*ere it was that Jimmy would imprison me, with typical care to restrain any show of sadistic delight, knowing well that a revealing chuckle or two might betray his evil to Mother. When he shoved it, the bed went inside the wall horizontally, and my clearance was less than a foot; so, besides fear of this lack of room to rise up as I lay breathing ever so slowly in the total darkness, there were strong twin terrors of realization: one, that I couldn't scream for release or Jim would surely beat me, and, two, that any yelling would also unnecessarily hasten to extinguish the all-too-small supply of oxygen.*

This claustrophobic experience had an unexpected effect that may prefigure Cassady's subsequent affiliations with stimulants—"a strange, pleasant quickening of my brain's action, which was disturbing enough to frighten, yet resisted any rigorous attempt to throw it off and return to normal-headedness." A similar transcendent effect is present in young Neal's early experience at the disused Pride of the Rockies flour mill: "Everything was dead, still, no activity, and no sound, save one thing: hundreds of solar-energized flies buzzed over me. I felt in a tomb, so isolated was I by the thick walls from crumbling 20th Street Viaduct, only yards away." Neal's boyhood relationship with his older male half-siblings—whom he called the "Dark Brothers"—was antagonistic. In *Visions of Cody*, Jack described an encounter between Cody and one of his half-brothers later in life, portraying him as a more realistic or conventional type apparently on good terms with his errant sibling, if only grudgingly agreeing to assist him in matters automotive and financial.

Most armchair Beat fans know the Kerouac line, "Down in Denver, all I did was die." Far fewer recognize it as the setup for a punch line consisting of the unexpected appearance of human sport interrupting his fatalistic train of thought and reminding the author of family ties and friendship, as noted in *Visions of Cody*: "Suddenly I came to a softball game under bright floodlights, with earnest glad young athletes but amateurs rushing pell-mell on the dust to the roar of audiences made up of their admiring mothers, sisters, fathers, and footman buddies."

Recounting the same moment in *On the Road*, Jack Kerouac described attending a baseball game at Sonny Lawson Park one night, among "all humanity, the lot," at the corner of 24th and Welton Streets in Denver's Five Points neighborhood. He is said to have "sketched" parts of that novel

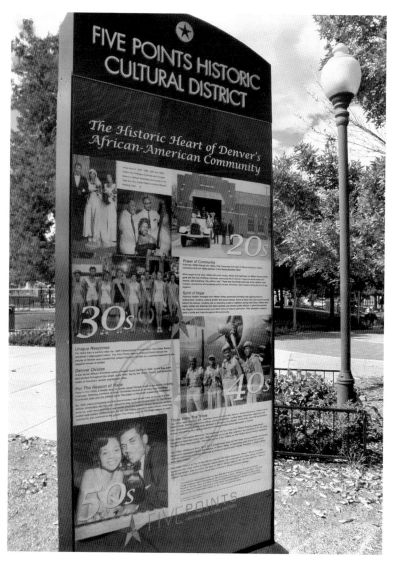

Five Points Historic Cultural District sign. *Photo by Michael Scalisi.*

and parts of *Visions of Cody* "near the gastank and the softball field" at "23rd and Welton or 25th." Sonny Lawson was the first field in Denver to host Negro League baseball games, and on August 9, 1972, the year *Visions of Cody* was published, it became the first park in Denver dedicated to an African American: Sonny Lawson, a Denver native who founded the Radio Pharmacy at 2601 Welton Street and ran it for more than fifty years. Lawson

THE DENVER BEAT SCENE

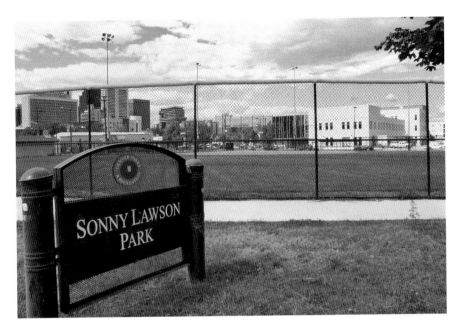

Sonny Lawson Park. *Photo by Michael Scalisi.*

was also east Denver district executive for the Democratic Party for more than two dozen years.

John Clellon Holmes is among those lauding *Visions of Cody* as Kerouac's greatest work, having commented that because Jack was not a native English speaker (Jack's family spoke a French Canadian dialect called *Québécois*), his understanding of the language's possibilities and potential effect was therefore fresher and more adept, especially toward the book's conclusion, where Jack draws a line across the top of the page and retells many of the events he wrote about in *On the Road* with less staginess and more frank emotional detail.

NEAL AND ALLEN AND DENVER

In the summer of 1947, Allen Ginsberg moved into a basement apartment at 9th and Grant Street (currently the site of a Denver Public Schools administrative office) during a period when Neal was out of town. He felt drawn, like Kerouac, to be physically closer to the roots of this extraordinary being who had appeared coincidentally at the same time Allen was sloughing off the stiffened strictures of conformity and pretense under which he'd been living—denying his homosexuality and serving as his mentally ill mother Naomi's confidant when his father, Louis Ginsberg, would not, as later recounted in Allen's poem "Kaddish," published by City Lights in 1961.

Neal Cassady also turned to Allen in his search for tips on how to write, taking advantage of his friend's attraction to him to enact a temporary period of extreme closeness between the two men in New York days, as noted in the Original Scroll:

> *They rushed down the street together, digging everything in the early way they had, which later became so much sadder and perceptive and blank. But then they danced down the streets like dingledodies, and I shambled after as I've been doing all my life after people who interest me, because the only people for me are the mad ones, the ones who are mad to live, mad to talk, mad to be saved, desirous of everything at the same time, the ones who never yawn or say a commonplace thing, but burn, burn, burn like fabulous yellow roman candles exploding like spiders across the stars and in the middle you see the blue centerlight pop and everybody goes "Awww!" What*

did they call such young people in Goethe's Germany? Wanting dearly to learn how to write like Carlo, the first thing you know, Dean was attacking him with a great amorous soul such as only a con-man can have. "Now, Carlo, let me speak—here's what I'm saying." I didn't see them for about two weeks, during which time they cemented their relationship to fiendish allday-allnight-talk proportions.

Ginsberg wrote a collection of poems called "The Denver Doldrums" concerning his lovelorn obsession with Neal at the time, as portrayed by Jack in the Original Scroll of *On the Road*:

The Mountains—the magnificent Rockies that you could see to the West from any part of town—were "papier mache." The whole universe was crazy and cockeyed and extremely strange. He wrote of Neal as "a child of the rainbow" who bore his torment in his agonized cock. He referred to him as "Oedipus Eddie" who had to "scrape bubblegum off window panes." He referred to Brierly as "dancingmaster death." He brooded in his basement over a huge journal in which he was keeping track of everything that happened every day—everything Neal did and said.

Allen eventually wrote another collection entitled "Dakar Doldrums," inspired by his time in that port as a merchant seaman in and around that region of Senegal. Both volumes in the series remain unpublished. Neal and Allen had fun times in Denver, in Civic Center Park and on the lawn of the City and County Building, as recounted in "The Green Automobile." Passages in the Original Scroll give a sense of a deliberate intellectual melding on Allen's part coupled with a suggestion of physical intimacy that Neal never completely consummated due to his prevailing heterosexual urges and involvements with multiple women.

Beautiful Denver University student Carolyn Robinson's apartment at the Colburn Hotel was one block north of Allen's pad. On one occasion, she returned there unexpectedly to interrupt Neal; his first wife, Lu Anne; and Allen Ginsberg naked in bed together. From her memoir, *Off the Road*:

I tiptoed up the stairs and, hoping to surprise him, gingerly turned the doorknob. He did the surprising. The scene before me stunned my senses as if I'd run into a wall. There in our bed, sleeping nude, were Lu Anne, Neal and Allen, in that order. Neal raised his head and muttered something, but my feet were already stumbling back down the stairs and out…I should be

The Mile-High Legacy of Kerouac, Cassady & Ginsberg

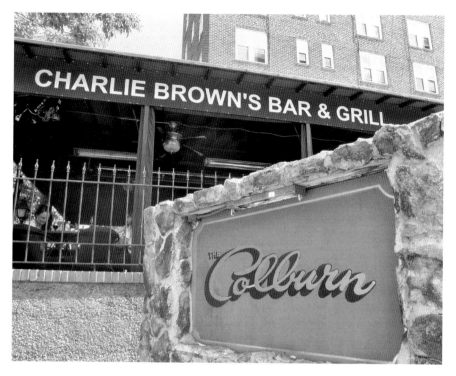

Colburn Hotel/Charlie Brown's Bar & Grill. *Photo by Michael Scalisi.*

grateful that I had escaped in time. I would forget the past six months and the man I'd met and loved, Neal Cassady.

The way Lu Anne told it, when interviewed by Gerald Nicosia, "When the three of us went to bed together, Neal always used to be in the middle… and Allen and I would be on either side of him. The two or three times we all actually had sex together, it was very nice. There was nothing obscene about the sex we had with each other—nothing you couldn't show on a screen or that you'd need more than a PG 13 rating for."

Neal followed Carolyn from Denver to San Francisco five weeks later, and they made up. The two married, and Neal began his effort at fatherhood and husbandry. Carolyn Cassady often stated her strong wish that more attention were paid to Neal's prodigious and successful efforts in the role of husband and father. As one whose entire life's purpose was consciously dedicated to overcoming his limitations, these may be regarded as the apex of his character. There soon transpired a relocation of multiple Beats to the Bay Area, with Lawrence Ferlinghetti's City Lights Books in that city publishing

books by several Beats, including Allen Ginsberg's *Howl*, the first live reading of which, at San Francisco's Six Gallery, was attended by Kerouac, Gary Snyder and others and memorialized in Kerouac's *The Dharma Bums* (1958).

Allen Ginsberg's reputation grew and changed over the years. As a founding Beat, he was an overly self-conscious, hyper-literate tagalong before causing a historic stir with *Howl* (which was given the filmic treatment in 2010 by directors Rob Epstein and Jeffrey Friedman). Ginsberg's role as a dedicated and undeniably effective promoter of all his friends' writings after achieving success is impressive—due in part to Allen's networking, William S. Burroughs's *Naked Lunch* and Jack Kerouac's *On the Road* came to print. In 1968, he was the bearded, bald peacenik chanting, "Om Ah Hum," playing his harmonium, crashing the Democratic Convention with Burroughs and Jean Genet, getting tear-gassed and narrowly escaping without serious injury. By 1972, when he wrote something for Kerouac's *Visions of Cody*, he could afford a higher vantage on the Denver street life. Chris Challis wrote of Allen's changing relationship to Denver over the years:

> *When he came West looking for Cassady and courting rejection, Ginsberg lived on a* [formerly] *sleazy street called Grant. When he wrote* Visions of the Great Rememberer *to preface* Visions of Cody *he was up in the air-conditioned comfort of the Denver Hilton and it was thirty years on and he was bald and famous. Kerouac was ten years dead but the bums were still there. The poet addresses himself to the timeless things.*

NEAL'S YOUTH IN DENVER

Neal Cassady acquired the vitality and dexterity with which he inspired the Beats into existence as a self-taught kid straining to outgrow his subordinate social placement both inwardly and outwardly through invented feats of strength. Every morning on his way to Ebert Elementary, young Neal passed the carved marble benches outside the downtown post office and the five-pointed intersection of streets, performing self-invented athletic routines while dribbling a handball. A few years later, Cassady enrolled at East High School on Colfax Avenue ("What do you do to an Angel you meet? You get down on your knees or you can pray on your feet. East Angels, East Angels!"). He spent most of his time cutting class as a prolific car thief, womanizer and chief of Larimer Street pool hall gangs, meanwhile serving as an altar boy at Holy Ghost Catholic Church on California and 20th, still standing (although presently surrounded by a modern office building complex) just where Broadway cuts alongside California. *The First Third* recounts his route as a child from the Metropolitan flophouse on Larimer Street—then a skid row, these days a thriving nightclub district—past the Holy Ghost Church and the U.S. Post Office bench, with its cryptic motto "IF THOU DESIRE REST, DESIRE NOT TOO MUCH" carved into white marble, all the way to the I-shaped elementary school he attended, still standing at 410 Park Avenue West. From *The First Third*:

> *My route to Ebert was always a careful zig-zag. The game was to find hurrying shortcuts, and to not waste a step, especially by the crime*

The Denver Beat Scene

Holy Ghost Church, where Neal Cassady was an altar boy. *Photo by Michael Scalisi.*

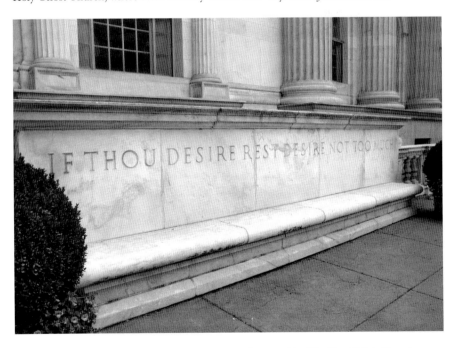

Bench outside the U.S. Post Office in Denver, referenced in *The First Third*. *Photo by Michael Scalisi.*

of missing a bounce of the dirty tennis ball's constant dribble. I also avoided cracks in the concrete, as a substitute for the impractical game of "Sidewalk's Poison" which...I developed into a Fine Art. I went past some of Larimer's row of bars and pawn shops, then up 17th Street to the newly created Federal Reserve Bank with its massive marble square-yard building blocks...its enormous bronze doors of scrolled bas relief...and I wondered the mystery of its vaults...Across Curtis Street's corner of candy company, parking lot, cheap hotel and cheaper restaurant, and up to Champa Street with the mighty colonnaded structure of the Post Office.

If Neal could transform all the miniscule everyday functions into exacting tests of skill, he could always keep improving. In other words, keep that ball bouncing, regardless of curbstones or traffic and anything else that might get in the way. As he learned in his pool hall days, it was all about angles. Perhaps because of his childhood privation, from a very early age he was inspired to turn every task into a feat of achievement. Far from idealizing dissipation, Neal was athletically devoted to improvement, encouraged by the notion engendered in him by "sleeping prophet" Edgar Cayce that "grace (i.e. generosity of spirit) beats karma."

In person, Cassady was reportedly always in motion. Kerouac called him one of the "mad ones...where the center-light pops and everybody goes, 'Awwwww!'" Tom Wolfe dubbed him "Za" in his book about the Pranksters, and his official nickname in that outfit was "Sir Speed Limit." An impressive person by any account, Neal C. was a zealous motorist who reportedly once set a record for the number of cars stolen within the Denver city limits in one season. A memorable scene in *On the Road* features Neal stealing multiple cars from a bar he and Jack have gone to, driving them away and back and parking again, even after a police officer has arrived, by coincidence, at the same location, and then going on to steal said agent's car in an impassioned demonstration of his inherent vitality, like one possessed. Kerouac paid multiple tributes to the impression Neal made as a charmed daredevil among them, as illustrated by the following dream sequence from *Visions of Cody*: "In other dreams when I go to San Francisco to see him, and we descend the mighty hills in a car, one time he fell out of the car in his attempts to show driving tricks, I closed my eyes exasperatedly to die but he miraculously jumped back into the car and righted it." Whole sections of *Visions of Cody* are composed of transcribed tape recordings of Jack, Neal, Carolyn and others talking. True to form, it was Neal who inspired Jack Kerouac's appreciation of this then brand-new technology in a series

of letters designed to incite a visit to his California home. Neal sought to encourage his appeal to Jack as a spontaneous person by introducing the first near-instant method of capturing human experience.

Neal also pioneered a continuing trend in American spirituality with his early acceptance of channeling by "sleeping prophet" Edgar Cayce after discovering psychologist Gina Cerminara's book, *Many Mansions,* while cleaning the train cars one day at the SP railroad. The book detailed and analyzed Cayce's readings, diagramming the function of reincarnational karma as channeled by Cayce, as well as how to beat that law with grace. Neal was immediately convinced of this philosophy's verity. His mania communicated to Carolyn, who became convinced herself and whose own pursuit of Cayceana was lifelong. Neal and Carolyn's involvement with the athletic Cayce approach served to disharmonize them with their closest Beat friends, who—beginning, arguably, with Kerouac—had developed a fixation on less practical Buddhist ideals like the "meaninglessness of everything."

Toward the end of his life, Neal was known for talking constantly, on multiple levels at once, habitually assuming the likeness most appreciated by those whose companionship he craved. This was a logical development of the instincts forged begging change for his father and the other bums in Denver streets as a child and testifying in court when his dad ran afoul of the law. A lifelong drive of Neal's was the desire to impress others positively, as they represented acceptance from the greater world from which he felt estranged.

Even misanthropic writer Charles Bukowski had a favorable impression of Cassady after their sole meeting at Open City publisher John Bryan's apartment shortly before Neal's death in Mexico. "He was a little punchy with the action, the eternal light, but there wasn't any hatred in him," wrote Bukowski in *Notes of a Dirty Old Man.* "You liked him even though you didn't want to because Kerouac had set him up for the sucker punch and Neal had bit, kept biting. But you knew Neal was O.K. and another way of looking at it, Jack had only written the book, he wasn't Neal's mother. Just his destructor, deliberate or otherwise." Appropriately enough, Buk's encounter with Neal involved a little crazy lucky driving on two wheels. "B. got up in front with Neal and the ride began. Straight along those slippery streets and it would seem we were past the corner and then Neal would decide to take a right or a left. Past parked cars, the dividing line just a hair away. It can only be described as a hairline. A tick the other way and we were all finished."

During their time on the road, the Merry Pranksters had a saying: "Stay in Your Own Movie"—meaning live out the plot of your choice, be the star of your life and don't let anyone else call your shots. While the forces

The Mile-High Legacy of Kerouac, Cassady & Ginsberg

Detail from the Mutiny Information Café mural, with Charles Bukowski pictured. *Photo by the author.*

of authority were movies of distrust and punishing evil, the Pranksters were living out one of awakening trust and goodness. Staying in one's own movie also included guessing others' movies and behaving contrarily to their expected plot points. Whether he said the phrase first or merely embodied it as a former beggar, prodigious car thief and womanizer, Cassady was its living exemplar. Despite its essential thematic kinship to making art out of one's life, as Jack did, the phrase "Stay in Your Own Movie" connotes a sense of kinetic participation in life absent in the former model. I bought a copy of Neal's book as a teen Beat fan and retraced his route from the flophouse on Larimer Street Ebert Elementary, also still standing under the same name, though the bricks have surely all been changed. If you think about it, this is analogous to personal history after it's been fictionalized, as Jack Kerouac did with his own. That was Kerouac's legacy to me.

The Denver Beat Scene

The 20th Street Gymnasium. *Photo by Michael Scalisi.*

When I discovered the Beats as a teen, I started fictionalizing my life right away, starting with my own name. People used to argue with me about that, saying my approach was inauthentic. "You're wrong," I protested. "It's authentically *my* perception." Names and details were changed at my discretion to reflect what I saw as the truth of whatever my life was doing. I tried to be authentic, striving after the personalized objectivity Kerouac seemed to represent—a contradiction in terms no less undeniably central to authentic human experience. These days, I prefer writing fiction, but every next project, no matter how fantastic, is inevitably rooted in something I've experienced.

Neal spent his adolescent and teenage years as a pool shark in Lower Downtown Denver, at the time a seedy district full of bars, flophouses, clip-joints and block-long pool halls, a part of his history referenced by Jack Kerouac in *On the Road* and made much of in *Visions of Cody*:

> *In the poolhall the hour was roaring. It was so crowded that spectators were standing obscuring everything from the street and somebody had the back door open simultaneously with the alley door of the Welton Street parlor so that you could see a whole solid block of poolhall from the north side of Glenarm to the south side of Welton interrupted only by a little tragic alley of shadows with a garbage can, like looking down a hall of mirrors*

over a sea of angrily personalized heads and islands of green velvet, all in smoke. To Cody it was a vision, the moment of his arrival that everybody was waiting for.

In *Visions of Cody*, Kerouac sketched Neal's apprenticeship to the hunchbacked Larimer Street pool shark Tom Watson. This character was based on a Denver man with a clubfoot named Jim Holmes. In the book, Cody presented Watson with the Dickensian proposition that if he'd teach Cody everything he knew about shooting pool, Cody would provide him in return with a crash course in philosophy, his mania at the time:

> *Watson looked amazed and dropped his superior pose out of sheer perplexity... what was he expected to do with a kid rushing up to him and saying "Do you want to learn philosophy from me" with a wag of the finger, sly eyes, neck popping with muscles like a jackinthebox straining at the world for the first time with a vigorous, evil spring..."i.e. you teach me to shoot pool" (pointing at himself) "and I teach you" (socking Watson in the chest with his forefinger and really hurting him) "further into psychology and metaphysics" (Cody mispronounced it "metafsicks" only because at this time he just hadn't carefully looked at it yet and when he did several weeks later it caused him tremendous private grief to remember this)...Watson's first, real, and genuinely kind impulse was to quiet Cody down. "My land!" he said to himself. "He's practically crazy from being hungry I bet!"*

As Cody/Neal tells it in the tape-recorded section of *Visions of Cody*, he'd come to the conclusion that "the thing that really counted" was philosophy until another Denver friend, Val Hayes (real name Hal Chase, Neal's fellow East High student who went on to Columbia University in New York), startled him by responding immediately, "I should think that the...poet is much more important than the philosopher." At first, Neal was stupefied, "but suddenly I realized that the philosopher was not—that the poet was more important than the philosopher, you see." In time, Neal's realization led him to covet the knowledge of how to live life as a writer, and this led to his trip to New York to meet Jack and Allen and John Clellon Holmes and Burroughs and the rest. Cassady was central to this group. Known as an inept gambler who used his intelligence to avoid fights but who could perform with great prowess on any athletic field, he worked irregularly but was central to social activities, often boosting a car or renting a moving truck that he filled with mattresses to ferry the gang back and forth to parties in

The Denver Beat Scene

the mountains, to Elitch Gardens for dances or out to the Eastside Tracks for midget auto races. The group was, for the most part, law abiding, composed of members attending college as well as working. They took frequent breaks at Lloyd's of Denver, at 15th and Glenarm, which had a bar downstairs where no one checked IDs, in an area ringed with bars and small hotels where Neal was rumored to bed girls between pool games and drinks. Lu Anne Henderson's mother tended bar at McVittie's restaurant, and Lu Anne first saw Neal there picking up his girlfriend, a McVittie's waitress much older than himself.

The significance of Neal's pool shark days as preamble to the various phases of his wild public life is given the fictional treatment in Stephen T. Kay's 1997 drama, *The Last Time I Committed Suicide*, starring Thomas Jane and Keanu Reeves. This film, set partly in Denver, is, in large part, a treatment of events described in Neal's "Joan Anderson Letter," with scenes cut when necessary to provide backstory (emulating his prose style in the letter itself). Several scenes are set in poolrooms, with Jane playing teenage Neal and Reeves as Neal's mentor and co-worker at the tire-recapping plant, Harry. Harry is film-Neal's first example of the "con man mystique" for which the real-life Neal would become so acclaimed. One more appropriation of a life story verging on myth to deliver life lessons via art, perhaps part of his karma. Denver still hosts a thriving pool scene, with some important parts still centered in Lower Downtown and Five Points, although the management has certainly changed since the '40s, along with the area's character, from a bustling skid row famed all over the West to an upscale nightclub district. This book is all about how things change.

JACK AND ED WHITE AND DENVER

Edward D. White Jr. (born on February 2, 1925), a Fellow of the American Institute of Architects, is a Denver-based architect whose forty-year practice (1955–95) focused on contemporary architecture and historic preservation. White met Jack, Allen and others at Columbia University in the '40s and was a lifelong friend to Jack Kerouac from 1947 to Kerouac's death in 1969. A catalogue of the collected correspondence between *On the Road* author and Beat king Jack Kerouac and Colorado native artist and architect Ed White, who helped design the Boettcher Memorial Tropical Conservatory and Mitchell Hall in the Botanic Gardens, is of interest to anyone looking for Denver Beat factoids. For example, so close was Jack Kerouac's relationship with Denver that he developed the code word "Elitch" to refer to marijuana smoking, having enjoyed that activity in the Denver amusement park by that name on more than one memorable occasion. "How Elitch prevents one from writing clearly," Jack wrote in one letter to Ed White. "2,000 American novels are published every year repeating the same old formulas that have failed and failed and failed…Does any of this make sense or is it pure Elitch? That too is another problem I'm dealing with."

While the complete text of each letter is never quoted in this catalogue, significant excerpts are given, along with illuminating commentary by White, characterizing the nuances of the friends' correspondence. The collection of correspondence between the two, valued at $1,250,000 (!), spans the years from 1947 to 1969, covering the span of Kerouac's career as a novelist, as well as all the ups and downs of his troubled life. As Jack put it in a letter to

Ed White written and sent in 1949, Neal represented something to him that he saw as alien and primitive, "more instant and interesting" than himself:

> *I can either be like Neal and be savage...or I can curb that for sweeter things, sweeter intentions, sweeter thoughts, greater life. Words don't work. It's not that one has to be philosophical...but beyond that, simply that one can take his choice and enjoy the freedom of the will. I feel great peace. I'll miss the gutters of Paris, the sidewalks where Stendhal, Dostoevsky, Rimbaud and Wolfe walked...I'll miss all...and always do...but beyond mere happiness there is more, dear joy, gladness, being here or there or everywhere and jumping in the air.*

In 1970, *Titanic* survivor "Unsinkable" Molly Brown's House at 1340 Pennsylvania Street in Denver's Capitol Hill neighborhood, a Denver landmark, was threatened with demolition. White led the efforts to preserve the mansion, and this led to the establishment of Historic Denver Inc., of which White was a founding board member, contributing to the establishment and preservation of multiple sites around Denver. In 2001, September 14 was declared "Edward D. White Jr. Day" by Mayor Wellington Webb, and on May 18, 2010, Edward D. White Jr. was honored with the Dana Crawford Award for Excellence in Historic Preservation by Colorado Preservation Incorporated. Two more Denver Beat friends deserving mention in this connection are Beverly Burford, the model for "Babe Rawlins" in Kerouac's *On the Road*, who died of a stroke in Denver in 1994, and her brother, Bob, both part of the Kerouac/White circle. After graduation from Columbia, Bob went to Paris with Ed White and Frank Jeffries. He became an editor at *New Story Magazine* and encouraged other editors to read and publish Kerouac.

LU ANNE HENDERSON

Former Denver resident Lu Anne Henderson (1930–2010) was among Neal Cassady's most esteemed female connections, a person with whom he stayed in contact to various degrees from the beginning of their relationship in Denver until just near the end of his own driven life, reportedly showing up at her California doorstep in the Merry Pranksters' multicolored Day-Glo Acid bus, "Furthur," only to be gently turned away as a part of Lu Anne's past no longer fitting with her present. Her story is told in her own words in *One and Only: The Untold Story of On the Road*, co-authored by Gerald Nicosia, who founded his writing career on books about the Beats (in particular a biography of Jack Kerouac called *Memory Babe*), and Anne Marie Santos, her daughter. In a taped interview with Nicosia, Lu Anne described their first meeting with Jack upon visiting Columbia in 1946 with Neal:

> *When we met Jack at Langston Hall, several of the fellas were already there—five or six of them. Allen was there, probably Ed White too—I can't remember who all. And then Jack happened to walk in. Well, Allen had been telling Neal that he wanted him to meet Jack, and then all of a sudden: "This is Jack Kerouac!" And of course when Jack came in, especially in those days, any girl couldn't help looking at him. Jack commanded attention from the female because he was so pretty...And of course Neal was instantly aware of it, which I think sort of attracted and repelled him at the same time. In a way, that was Neal's and Jack's*

The Denver Beat Scene

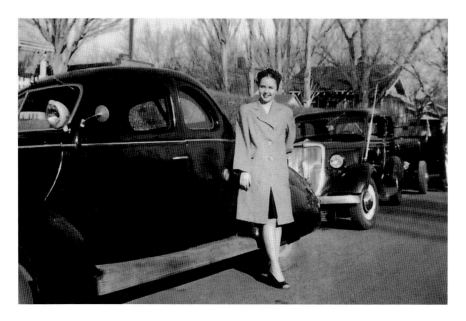

Lu Anne Henderson, Neal Cassady's first wife, in Denver. *Courtesy of Brenda Knight, Cleis Press.*

immediate reaction to one another, because they both had mixed feelings about the other.

One and Only gives voice to the Denver cop's daughter who inspired the faintly rendered character of Dean's teenage girlfriend Marylou in *On the Road*. Like Jim Jones's *Use My Name: Jack Kerouac's Forgotten Families* and Joyce Johnson's *Door Wide Open*, Nicosia's collaboration with Lu Anne and her daughter provided the backstory to a classic American cultural stage, broadening readers' impressions of that cherished chestnut:

> *Believe me, that trip across the country was a test of endurance for all of us. It was a grueling thing. I don't remember if Jack wrote much about that or not. Again we had to drive with the windows down because of the frost— and whoever wasn't driving, the other two had to sit pressed against each other. Just to keep warm we had to hug each other…And then, somewhere along the way, we slid off the road and landed in a damn ditch!*

Actress Kristen Stewart, who plays Marylou in *On the Road* and has reportedly been a fan of *On the Road* since her teens, participated in a "Beat boot camp" along with the actors playing Sal Paradise (Jack Kerouac) and

Dean Moriarty (Neal), during the course of which she reportedly took the time to listen to the entirety of Nicosia's interview with Henderson. Stewart said that in her opinion Lu Anne's "estrogen" was the necessary element to seal the Beat Generation's success as a movement. According to Lu Anne, fame was a trap for them both:

> *You see, both of them were desperately trying to get out of it, one way or another—get out of the roles they'd been forced to play. And eventually just to get out of life itself. I felt from Neal, and the things I read about Jack, and the things I saw, that both of them were just hell-bent to destroy themselves...They wanted to let go, and they both took their own way of doing it, but they were trying to rush it. They were trying like hell just to get out of the whole situation. They just wanted out.*

Carolyn Cassady (née Robinson)

A graduate of Bennington College, Denver University student Carolyn Robinson rented an apartment at the Colburn Hotel Apartments at 980 Grant Street in March 1947. Carolyn was pursuing her MA in fine arts and theater arts at the University of Denver, 2199 South University Boulevard, while working as a teaching assistant and beginning a theater arts department for the Denver Art Museum on 14th and Broadway. The Colburn Hotel Apartments and the piano bar on the lower level, Charlie Brown's (sure to have hosted several intimate encounters with Beat luminaries like Carolyn, Neal, Allen and Jack), have been in operation since before Carolyn's tenancy. Allen Ginsberg stayed at Carolyn's apartment at the Colburn for a few weeks before finding his own apartment. Chris Challis also wrote about Carolyn's time in Denver:

> *As Camille in On the Road she appears only fleetingly and has little depth compared to even minor male characters. Ed Dunkel or Carlo Marx remain in the memory as the loping laconic Westerner or the young Jewish intellectual with the burning eyes, while Camille is little more than a stereotyped deserted wife. The lady herself feels that the name indicates the way she was at the time—with "Dean" buzzing energetically between her and "Marylou" and his other women, "Sal" looking on in admiration and scarcely admitting that such behavior has the potential for causing misery. Carolyn Cassady's autobiography…exhaustively catalogues the disillusionment of this time.*

The Mile-High Legacy of Kerouac, Cassady & Ginsberg

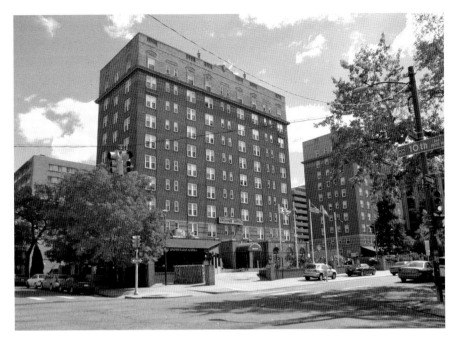

The Colburn Hotel. *Photo by Michael Scalisi.*

Denver University campus. *Photo by Michael Scalisi.*

Carolyn and Neal began their affair, although at the time he was still married to Lu Anne Henderson. When interviewed by literary magazine *Notes from the Underground* in 2008, Carolyn Cassady (1923–2013) pointed out that "the Beat Generation was something made up by the media and Allen Ginsberg." In the same interview, Carolyn went on to say that Jack Kerouac could not stand the public image that was created for him. The same can certainly be said for Neal, whose driving aim in life was to outsize his shabby roots with each next gesture. Because of this predisposition, Kerouac's sensationalizing of his friend, the Barber's Boy, however well intentioned, may have done more harm than good by effectively fixing him in popular consciousness at a certain stage of development. My friend Miranda says that the longer a plant's in the same soil, the more its roots take on the shape of the pot.

Denver Jazz Scene, 1940s

In the evenings, Carolyn, Neal and Jack made the jazz scene in Five Points, frequenting spots like the Roxy, the Rossonian and the Casino Cabaret. Kerouac wrote this outsider's view of the predominantly nonwhite neighborhood in *On the Road*: "At lilac evening I walked with every muscle aching among the lights of 27th and Welton in the Denver colored section, wishing I were a Negro, feeling that the best the white world had offered was not enough ecstasy for me, not enough life, joy, kicks, darkness, music, not enough night." Jack's phrasing may sound corny these days, but the Beats' deliberate transcendence of the racial segregation of American society, including a love of jazz, was a fundamental part of their effect on public perception.

Carolyn moved to California in 1947, and Neal followed her there shortly after the events chronicled in *On the Road*. Neal's youngest child and eldest son, John Allen (named after both Kerouac and Ginsberg), for years shared a joke with his late mother, Carolyn, teasing her that she had "started it all"—meaning the whole of the cultural progression resulting from the Beat Generation to the Acid Tests to the Vietnam War to the Manson family—all by introducing Neal and Jack to the jazz clubs in North Beach outside San Francisco. No doubt they were grateful for the tip. Neal Cassady's love of jazz was maniacally sincere, as evidenced by this passage from *On the Road*'s candid Original Scroll:

> *The drummer, Denzel Best, sat motionlessly except for his wrists snapping the brushes. And Shearing began to rock, a smile broke over his*

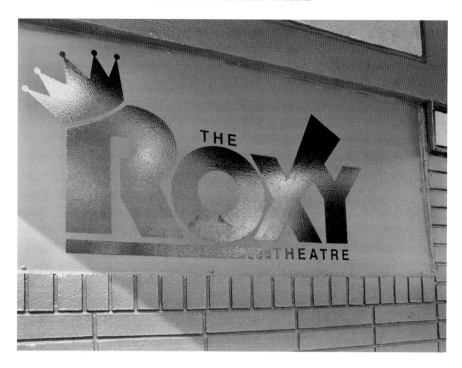

The Roxy. *Photo by Michael Scalisi.*

Roxy marquee. *Photo by Michael Scalisi.*

The Mile-High Legacy of Kerouac, Cassady & Ginsberg

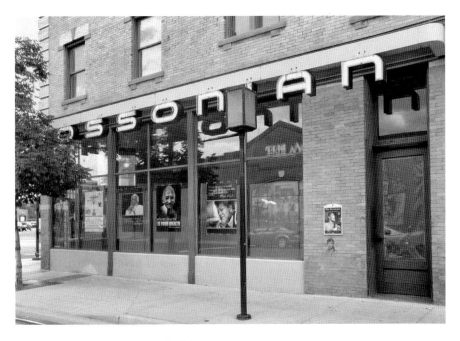

The Rossonian. *Photo by Michael Scalisi.*

> *ecstatic face; he began to rock in the piano seat, back and forth, slowly at first, then the beat went up, he began rocking fast, his left foot jumped up with every beat, his neck began to rock crookedly, he brought his face down to the keys, he pushed his hair back, his combed hair dissolved, he began to sweat. The music picked up. The bassplayer hunched over and socked it in, faster and faster…Shearing began to play his chords, they rolled out of the piano in great rich showers….Neal was sweating; the sweat poured down his collar. "There he is! That's him! Old God! Old God Shearing! Yes! Yes! Yes!"*

Kerouac, too, was known for his immoderate love of the "bop" music that predated jazz and then ran alongside it contemporaneously, as personified by Charlie "Yardbird" Parker, having once been invited to write a whole issue of avant-garde arts mag *Neurotica* devoted to the subject. He loved it so much that he favored the descriptor "spontaneous bop prosody" for his own captivating style of writing. The Five Points area was a Harlem in the West, full of jazz clubs, and Neal and Jack and all their friends, including Ginsberg and the Hinkles (who met while Al was looking for a jazz club in San Francisco), partook of its offerings when in Denver.

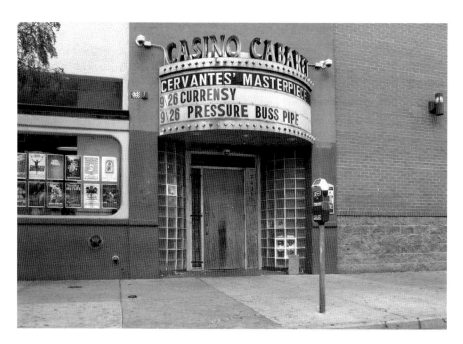

Casino Cabaret. *Photo by Michael Scalisi.*

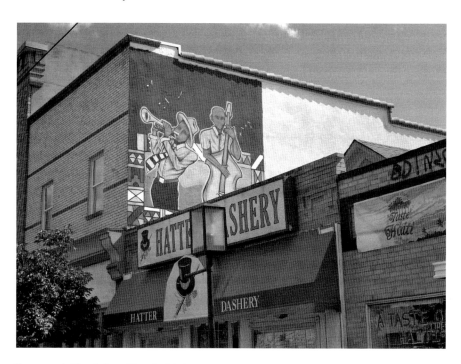

Jazz mural, Five Points. *Photo by Michael Scalisi.*

Interviewed by Gerald Nicosia for *One and Only*, Neal's first wife, Lu Anne Santos (née Henderson), observed that the racial hostility her crowd encountered in black jazz clubs on the West Coast was far more severe than it ever had been in Denver:

> *Neal would go anywhere without thinking. But until then, none of us had ever worried about racial problems either. We'd never encountered any kind of racial anger before. In Denver, we used to go to the Rossonian, over in Five Points, which was a black area, but we never encountered that kind of hostility. And let me tell you, it was a bum experience. It scared the hell out of Jack and me. I don't think Neal really believed us even though we told him all the things that had happened while he was standing at the stage.*

The above passage effectively conveys Cassady's appealing manner of avoiding the prevalent pitfalls of human interaction simply by refusing to include them in his script, prefiguring the phrase "Stay in Your Own Movie," which would become popular among the Merry Pranksters when Cassady assumed the helm of their psychedelically painted Day-Glo bus years later. Neal was known for his ability to outwit even the most clever traffic cop during this period, demonstrating the immunity provided by unqualified engrossment in experience which was his singular magic.

For his part, in imitating the loops and wild rhythms of this improvisational music while attempting to write without forethought, Jack Kerouac furthered and enhanced his pact with spontaneity. One of Neal's favorite jazzmen was Coleman Hawkins, while a special favorite of Jack's was Charlie Parker, whom he idealized as dumb-saint of the mind. From the Original Scroll of *On the Road*:

> *[A] kid in his mother's woodshed in Kansas City, blowing his taped-up alto among the logs, practicing on rainy days, coming out to watch the old swing Basie and Benny Moten band that had Hot Lips page and the rest—Charley Parker leaving home and coming to Harlem, and meeting mad Thelonious Monk and madder Gillespie…Charlie Parker in his early days when he was flipped and walked around in a circle while playing.*

Another favorite Five Points venue for Jack and Neal and company was the Casino Cabaret, well known to Cassady as a Denver jazz lover, which hosted acts like Duke Ellington and Ella Fitzgerald in its heyday. The Casino Cabaret (2637 Welton Street) has continued to draw an audience over the

El Chapultepec Cantina/Bar/Café. *Photo by Michael Scalisi.*

years, featuring acts like James Brown, B.B. King and Ray Charles. The still thriving establishment currently features popular jam band, funk and hip-hop acts.

Which brings us to El Chapultepec, at 1962 Market Street on the edge of Five Points, a Denver bar long renowned for its connections to the jazz scene. Although never mentioned by name in any of Jack's writings, one book about Denver's best dive bars noted that Kerouac "washed up there once," and the late owner of the club, Jerry Krantz, said in an interview that he remembered Kerouac and his friends drinking at the bar. The scenery surrounding El Chapultepec has changed drastically since Kerouac's patronage with the advent of Coors/Invesco field and its dozens of attendant sports bars, but the club remains a paragon of Denver's still thriving jazz scene, open daily from 11:00 a.m. to 2:00 a.m. and featuring live music every night.

Jack and Neal's love of bop and jazz are given voice throughout several of Jack's books, as in this excerpt from the tape-recorded section of *Visions of Cody*, epitomizing the unrestrained style of talk common among smokers

Graffiti outside El Chapultepec: "Jack Was Here." *Photo by Michael Scalisi.*

of T (cannabis), new to them at the time, like tape recording conversations was new to the public:

> CODY. *Yeah! Boy! He blasts like Louis Armstrong! Zoom! It's gone in two roaches…it makes a roach out of a joint in two puffs.* (everybody laughing) *That sonumbitch is high, man…No, he's going, ffff, sss, man he just keeps going up, up, up, and I'm watching down, down, down….Now.* (laughs) *Ah look at him!* (much blasting…Lester Young starts) (groaning and blasting) *No, what?* (Evelyn [Carolyn Cassady] speaks faintly from way back) *Oh yeah? Hey Jack.*
> JACK. *Huh?*
> CODY. *She's reading along here on a page and she says, "You and Jack had this exacts same conversation tonight"…the same paragraph…of Billie Holliday.*
> JACK. *Yeah.*

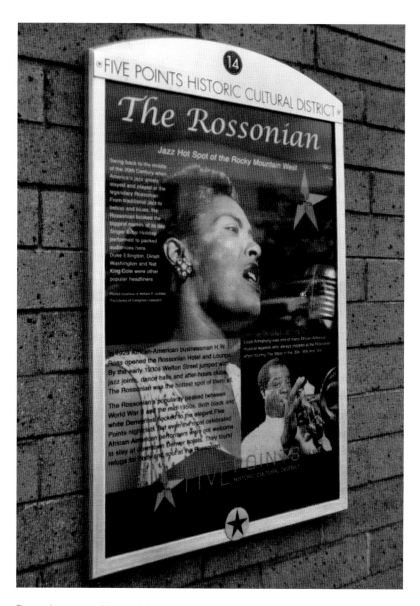

Rossonian poster. *Photo by Michael Scalisi.*

>*EVELYN.* (reads) *"Good morning heartaches"—"Good morning heartaches"—"yeah"...*

The Five Points Jazz Festival brings together a crowd every summer for one day of food, fun and excellent music. Since the tradition was founded

in 2004, the festival has reportedly grown in size and popularity on a yearly basis. From the website Denver Arts and Venues:

> *In 2014 we saw an attendance increase 16,000 visitors in 2013 to nearly 26,000. We added an additional 20 vendors to bring our number to 95 vendors in the marketplace, and added three more stages in 2014 bringing us to a total of nine stages hosting 35 bands (up from 23 in 2013). To accommodate these increased numbers, the festival area had to expand four additional blocks. This additional space included the Climax Lounge and Event Center…2014 also brought an extended series, Five Points Jazz Festival Presents: Rendezvous Sessions, monthly to the McNichols Building. This event series provided a sneak preview of the great musicians who will be played [sic] the 2014 festival…Five Points Jazz on Film returned for a second year on May 15 with a screening of "Bird," the biopic of the famed saxophone player, Charlie Parker and entertainment by Tom Tilton Jazz Ensemble.*

AL AND HELEN HINKLE

Another figure from the pool hall days Jack revisits in *Visions of Cody* is Slim Buckle (real name Al Hinkle, who appeared as Big Ed Dunkel in *On the Road*), presented as a sort of bemused giant given to long walks under the stars:

> *Slim Buckle was a great big figure going down those Denver streets between the rickety backs of houses that were completely suburban and respectable out front with lawns and sprinklers because the heat of the plains sun turns the grass brown, striding with bowed head in some kind of tremendous concentration of his own among the smoking incinerators, the brick ovens of Denver backyards…In fact Buckle went through these alleys (en route to the poolhall) with his hands in his pockets like Sad Sack but whistling… Trotting along like this, calm, lovely bemused, he approached the gang as though he wasn't six foot four at all.*

Long before the cross-country trip that made him pseudo-famous, Al had already traveled the world in the service and as a merchant seaman, not to mention several jaunts away from Denver to other parts of the United States, and he was far better traveled than Neal by the time Kerouac made his acquaintance. The story of Hinkle's hasty marriage to Helen Argee to help finance that *On the Road* zigzag is essentially true, although the couple remained married for forty-six years, until Helen's death in 1994. Al Hinkle was fictionalized as Ed Schindel in John Clellon Holmes's *Go*, with that book detailing the New York Beat scene before the events fictionalized in

On the Road, including Hart Kennedy's visit to the campus from Denver with his girlfriend Dinah (Lu Anne Henderson). In that book, Kerouac is Gene Pasternak, and Ginsberg is David Stofsky.

Called variously Slim Buckle, Big Ed Dunkel and Ed Buckle in different books by Kerouac, Al Hinkle was the strongest carryover besides Neal himself from Denver pool hall days to Beat history, due to the inclusion of characters based on him in Jack Kerouac's *On the Road*, *Visions of Cody* and *Book of Dreams*. In *On the Road*, Big Ed Dunkel takes Dean Moriarty's advice, abandoning his bride, Galatea Dunkel, in New Orleans (whom he only married to get more money for the seemingly aimless auto trip across the United States) with a railroad pass south to William S. Burroughs's farm in Texas, where she met Ginsberg, Neal, Times Square hustler Herbert Huncke, Burroughs, Joan, Billy and Joan's daughter, Julie. Al said that he'd be back in three days, which turned into three weeks. "Well, that was my immaturity," he explained in a taped interview at the Beat Museum in San Francisco. Al and Helen married one week after meeting each other and remained married until her death in 1994.

Born in the same year, 1926, Neal and Al met in Denver when they were both thirteen as fellow acrobats in a YMCA circus. From Al's website (www.alhinkle.com):

> *I got to spend time there and met Neal, who was also twelve. His father was well known to the police department—he spent most winters in the Denver jail as a trusty, giving the cons and the guards haircuts (he was a good barber when sober). Neal told me that the jailers would bet his father's barber tools out of hock so he could use them in lockup. Both Neal and I became friends and spent a lot of time together at the YMCA. They chose us to be acrobats in a YMCA circus, so we spent about 6 weeks practicing and tumbling. Because I was almost 6 feet tall (yes, at age 12!), I was the bottom man in the pyramids and the high wire act, and I was the catcher in the flying trapeze act. Neal was the flier, he would swing on the trapeze and do a somersault, and I would catch him. Of course there was a net, but we both got so good at it that we hardly ever had to use it. Life intruded though and we didn't see each other again until we ran into each other when we were 19. Because of the YMCA experience, I would joke years later that I was still trying to keep Neal from falling!*

The character of Galatea Dunkel in *On the Road*, meant as a fictionalization of Al's wife, Helen Hinkle (née Argee, 1925–1994), is representative of a narrow-minded practicality that the heroes of Kerouac's novel sought to outstrip and overcome, as noted in the Original Scroll:

The Denver Beat Scene

Al had just met a girl called Helen who was living in San Francisco on her savings. These two mindless cads decided to bring the girl east and have her foot the bill. Al cajoled and pleaded; she wouldn't go unless he married her. In a whirlwind few days, Al married Helen, with Neal rushing around to get the necessary papers, and a few days before Christmas they rolled out of San Francisco at seventy miles per, headed for L.A. and the snowless southern road… Neal and Al gave her the slip in a hotel lobby and resumed the voyage alone, with the sailor, and without a qualm. Al Hinkle was a tall calm unthinking fellow who was ready to do anything Neal asked him; and at this time Neal was too busy for scruples.

At this point in the book, Dean offered to deliver some furniture to Sal's aunt's house for his family, making two trips back and forth from Virginia to New Jersey and on the second trip bringing Sal's aunt back to New Jersey. Sal joined them, on the road again, smoking a pipe in a chair in the back of a truck full of furniture. The pack arrived in Paterson. Bull Lee called from New Orleans to tell them that Galatea Dunkel had arrived there and wanted to know what was happening with Ed. Camille (Carolyn) called, too. Then they call Carlo Marx (Ginsberg) in Long Island, who came over, seeming quieter, overall more serious and newly skeptical of Dean's recklessness, having spent some time at spiritual devotions in Indonesia, where he wrote the "Dakar Doldrums." Joining Allen in disapproval of Neal is Helen Hinkle, victim of said recklessness.

Feminism makes a bold appearance in the first published manuscript of *On the Road* when a woman—Helen Hinkle, as personified by Galatea Dunkel—denounces Neal for his irresponsibility and heedlessness of others. "Helen Hinkle was the only one in the gang who wasn't afraid of Neal and who could sit there calmly, with her face hanging out, telling him off in front of everybody." Considered as a character, Helen/Galatea is an exponent of women's reclamation of personal power in the 1950s. In *On the Road*, Kerouac notices a full-length painting of the mistreated Galatea hanging over Camille's couch during a brief stop at her apartment with Neal right before setting off on another wild cross-country jag and recognizes the private world of "loneliness and womanliness" created by the women while their joy-mad male partners were out getting their joy-mad kicks. Unfortunately for champions of gender equality, in the words of English Beat historian Chris Challis, "[t]his fits neatly into his preconceived, idealized image of homemaking womanhood absorbed from the dutiful, powerful Catholic matriarchies in which he was brought up… the women won their power by making themselves indispensable. Men might goof but women looked after babies."

JUSTIN W. BRIERLY

Neal met John and Lucille Brierly in approximately 1941. John, the wealthy descendent of a Denver pioneer, and his wife both loved to drink, and were in the habit of hosting "open houses." Family members less given to drink regularly cleared the place of loafers. A story goes that the ice man got sucked into one of these when making a delivery, and his boss had to tend to the wagon and its melted contents when he failed to emerge for a couple of days. This type of scene was attractive to young Neal, who began to hang out at the Brierlys' place, with the end result of meeting John's nephew, esteemed graduate of New York City's Columbia University, Denver lawyer and East High School English teacher and guidance counselor, Justin W. Brierly, who, upon running into shirtless Neal in his uncle's kitchen, asked him, "Who are you?"

"The question is," replied Neal with alacrity, "who are you?" which so impressed Brierly he landed Neal a place in East High School, where standards of inclusion were, at the time, very exclusive.

Justin W. Brierly (or "Denver D. Doll," as he's portrayed in Jack Kerouac's *On the Road*) played an instrumental role in the foundation of the Beat Generation of writers, having been the link of introduction in 1946 of Columbia students Jack Kerouac and Allen Ginsberg to a young man of his acquaintance, a seemingly incorrigible pansexual car thief from Denver by the name of Neal Cassady. Everything unfolded from that introduction. Kerouac also included references to Brierly in his book on Neal, *Visions of Cody*, as "Justin G. Mannerly" and in his *Book of Dreams* as "Manley Mannerly."

Brierly was apparently a major figure in their first associations, and while Denver D. Doll is a nonessential character in the published version of *On the Road*, Justin W. Brierly is a far more consequential player in the Original Scroll. He wrote early articles promoting Kerouac's first few books and organized a book signing for him at the Denver Dry Goods Building. Brierly helped direct the Central City Opera House Association from 1937 to 1948. This excerpt from *Visions of Cody* appears to characterize him fairly innocuously:

> [A]*cross the wide field with its spastic fires and purple skies…was propped all by itself there an old haunted house, dry gardens of Autumn planted round it by nineteenth-century lady ghouls long dead, from the weatherbeaten green latticed steps of which now descended Mr. behatted beheaded Justin G. Mannerly the mad schoolteacher with the little Hitler mustache, within months fated to be teaching Cody how to wash his ears, how to be impressive with high school principals—Mannerly now stopped, utterly amazed, halfway down, the sight of Cody and Earl Johnson furying in the road (almost getting killed too), saying out loud "My goodness gracious what is* this*?"*

A trustee of Colorado Outward Bound School, Brierly was also a board member of the American Council of Émigrés in the Professions and served as adviser to the Institute of International Education board. He was instrumental—as a graduate of Columbia University dedicated to the advancement of brilliant young men he encountered at Denver's East High—for introducing several Denverites, including Ed White, Al Hinkle and Neal Cassady, to Columbia students like Kerouac and Ginsberg. Brierly served as an assistant to the president of Colorado Women's College after retiring from his position as a guidance counselor for DPS at locations such as East High, where he met Cassady. In 1978, Mr. Brierly donated a stained-glass window from the Tears McFarlane House in the Cheesman Park neighborhood (80203) to the City and County of Denver after the mansion had been purchased for use as the Community Center. He died in Denver in April 1985 at the age of seventy-nine. His *Rocky Mountain News* obituary referred to him as "one of Denver's most distinguished educators." Brierly is believed to have been responsible for Neal's first homosexual experience.

The opera house in Central City remains a popular tourist attraction for residents of Colorado. A memorable section of *On the Road* that appears in

The Mile-High Legacy of Kerouac, Cassady & Ginsberg

Letter from Neal Cassady to Justin W. Brierly, formerly framed at My Brother's Bar. *Courtesy of My Brother's Bar.*

a slightly different form in the Original Scroll relates Jack's visit to Central City just after arriving in Denver to attend the opera there at Brierly's behest:

> *Central City became a ghost town, till the energetic Chamber of Commerce types of the new West decided to revive the place. They polished up the opera house and every summer stars from the Metropolitan opera came out and performed. It was a big vacation for everybody. Tourists came, from everywhere, even Hollywood stars…Only a few days ago I'd come into Denver like a bum; this afternoon I was all tacked up sharp in a suit, with a beautiful well-dressed blonde on my arm, bowing to dignitaries and chatting in the lobby under chandeliers. I wondered what Mississippi Gene would say if he could see.*

For years, a framed letter from Cassady to Brierly requesting the loan of a small bar tab payment hung framed inside a phone booth at My Brother's Bar (formerly Paul's Place, an early hangout of Neal's) at 2376 15th Street in the Highlands neighborhood (80202). The framed letter is absent today, but photocopies of it are available upon request from your server or bartender. My Brother's Bar, one block north of venerable Denver Bohemian coffeehouse Paris on the Platte, long a hangout for Denver's writers and poets, serves excellent food and drink at affordable prices. A transcript of Neal's letter follows:

> *October 23, 1844*
> *Colorado State Reformatory*
> *Buena Vista, Colo.*
>
> *Dear Justin;*
>
> *At the corner of 15th & Platte streets there's a cafe called Paul's Place, where my brother Jack used to be bartender before he joined the army, because of this I frequented the place occasionally & consequently have a small bill run up, I believe I owe them about 3 or 4 dollars. If you happen to be in that vicinity please drop in & pay it, will you?*
> *I see Phillip Wylie has written another book, "Night Unto Night" supposedly as good as "shower" it's called "Generation of Vipers." Peter Arno also has a new collection of cartoons out, "Man in a shower" it's called.*
> *They have the Harvard Classics up here, the five foot shelf of books, I've read about 2 feet of it, very nice, I especially enjoy Voltaire & Bacon*

The Mile-High Legacy of Kerouac, Cassady & Ginsberg

My Brother's Bar (formerly Paul's Place). *Photo by Michael Scalisi.*

(Francis). The football season up here has been a flop. We started out with grand plans; the guards told us if we looked good enough we would go to Salida to play & perhaps one or two other games on the out, but no go. However, I understand the basketball team may get to play some local highschools. Since the days are getting shorter, because of winter's approach, we get up at 5 o'clock now, instead of 4 as we had been, banker's hours, huh? I've been here 2 months today (the 23rd), how time does fly.

Please excuse the penmanship, as I can only see out of one eye; this morning I took the cows out to pasture, but on the way they ran out of the road into the corn field. The jackass I was riding couldn't run fast enough to head them, so I jumped off & started to tie him to a barbed wire fence so I could chase the cows on foot. Just as I had tied the reins to the wire he jerked so hard it pulled a staple out of the fence post and into my left eye. It gorged a chunk out of my eyeball, but luckily failed to hit the cornea. I may lost that eye.

<div align="right">Neal L. Cassady</div>

Jack's House in Lakewood and Denargo Market

Jack Kerouac's affinity with Denver was so strong that at one point he rented a house in Denver's Lakewood district (formerly Westwood) with his mother, Gabrielle, using proceeds from the sale of his first novel, *The Town and the City*, and fully intending to relocate permanently. He talked about it in this passage of the Original Scroll (published by the Kerouac estate in 2007), which didn't make the version of *On the Road* first published:

> In the spring of 1949 I suddenly came into a wonderful thousand dollar check from a New York company for the work I did [referring to the proceeds from his first published novel, *The Town and the City*]. With this, I tried to move my family—that is to say, my mother, sister, brother-in-law, and their child to a comfortable house in Denver. I myself traveled to Denver to get the house, taking great pains not to spend over a dollar for food all the way. In one day, hustling and sweating around the May-time mountain town, and with the invaluable assistance of Justin W. Brierly, I found the house, paid the first two months' rent on it and sent them a wire in New York telling them to come in. I paid the moving bill, $350.00.

As it turned out, Jack; his mother; his sister, Caroline (whom he called Nin); and Caroline's husband, Paul Blake, lived in Denver only from late May/early June to July 1949 before changing plans and returning to New

The Jack Kerouac Apartments. *Photo by Michael Scalisi.*

York—"it all fell through. They didn't like Denver and they didn't like being in the country. My mother was the first to go back; then finally my sister and her husband went back…I was suddenly left with nothing in my hands but a handful of crazy stars."

The Denver Beat Scene

During this visit, Jack tried working days at the Wholesale Fruit Market then located near East Brighton Boulevard and Delgany Street, but he didn't last long, as noted in the Original Scroll:

> *This was the place I had almost worked in 1947 with Eddy my roadbuddy. I was hired immediately. There then began a day of labor that I shall never forget. I worked from 4 o'clock in the morning clear to six o'clock in the evening, and at the end of that day I was paid eleven dollars and some change...I myself unloaded a boxcar and a half of fruit-crates in the entire day, interrupted only by one trip to the Denver wholesale houses where I lugged watermelon crates over the icy floor of a boxcar into the blazing sun of an ice-spattered truck and developed a mean sneeze.*

Time marches on. The location described here is currently the site of an apartment complex called Denargo Market in the RiNo district, where you can "nourish your creative lifestyle" like the Beats did. In the same spirit, three addresses on Sherman Street just south of the Capitol Building, called collectively the Jack Kerouac Apartments, are for "those with a unique style, just like the poet himself—a little off, unconventional, maybe, but attractive nonetheless." But the Kerouac family's former abode in Lakewood is still zoned as a place of residence.

NEAL CASSADY AS COUNTERCULTURAL ICON

Neal Cassady was the catalyst for what William S. Burroughs called "a cultural revolution of unprecedented worldwide extent." Even after the Beat Generation had faded from popularity, Neal remained at the forefront of countercultural activity in the United States as designated driver of *One Flew Over the Cuckoo's Nest* author and self-made superhero Ken Kesey's Magic Bus "Furthur." Neal drove Kesey's band of Merry Pranksters from Acid Test to Acid Test beginning in 1964, yakking incessantly through a loudspeaker, flipping sledgehammers shirtless at all the pit stops and embodying a living bridge from the last hip scene to the latest before ending up dead of exposure on the train tracks four years later. The presence of Neal Cassady in the Merry Pranksters offered to those who might otherwise have looked with skepticism on the group some evidence of continuity. He was a link with the genuine Beat past. Cassady had a terrific reputation in the hip scene by this time. He was thought of as the only true Beat—after all, he was the only one who made no money from it all. The others wrote about it—so the argument went—but Neal Cassady had lived it. To some, the fact that Cassady was one of the Pranksters certified Kesey's bunch as authentic.

Neal's fame as Beat Hero "Dean Moriarty" in *On the Road* was a prime factor in his subsequent inclusion among the post-Beat Pranksters. Because of this dual positioning, artists of multiple disciplines from Kerouac to the Grateful Dead have cited Neal Cassady's influence, stressing his importance in the history of creative expression as an artist whose life itself was his field of endeavor. Afflicted with hang-ups about

The Denver Beat Scene

Ken Kesey's bus, "Further." *Photo by Bataan Go Faigao. Courtesy of Wendy Woo.*

"writing well," to the degree that he only sweated out one deliberate effort in his lifetime, Cassady nonetheless continues to inspire a prodigious amount of creative output by others. Tom Wolfe's *The Electric Kool-Aid Acid Test*, which approximated the Pranksters' adventures by way of gonzo journalism, met with mixed reviews. The Grateful Dead has a song called "Cassidy," reportedly a combination of the author's thoughts on Neal—whom he knew from the parties at Kesey's place in La Honda, where the Dead were the house band—and another member's daughter (by name Cassidy). Kesey's collection *Demon Box*, published in 1987, includes a loving memorial entitled "The Day Superman Died."

LSD was still legal in 1964, but when the establishment interposed in the form of highway cops and traffic stops, Neal's sleight of mouth was an essential tool. He was able to bamboozle the officers with his improvised verbal legerdemain, freewheeling and frank and just beyond comprehension without arousing suspicion. The Pranksters were known for "tootling the masses" with plastic piccolos when they rolled through each town, including the one Neal used to punctuate his free-associative monologues while driving the bus. Cassady long had aspirations to play

the saxophone, as can be seen in his correspondence from the late '50s on, and owned a piccolo several years prior to the Pranksters' psychedelic jaunt, writing of it in multiple letters to Jack and Allen and others.

The sort of exuberant mythologizing of all the people in his life that Jack Kerouac practiced with such relish for so long, using recognizable pen names as if by unspoken agreement with the fictionalized subjects, is increasingly rare in today's marketplace. Part of seeing one's life as an author involves extrapolation—imagining what will happen next for characters displaying certain tendencies or what has happened previously to establish said tendencies—for example, a propensity to indulge in drugs like Neal/Dean/Cody. If metaphysicians are correct, that consciousness is a creative factor; that minds make lives, as it were, and the author must be careful not to "curse" his or her subjects with assumptions and predictions, as Kerouac, arguably, did with his friend Neal Cassady. In one sense, writing autobiographical fiction is an expression of total honesty. In another sense, it relegates everyone else to the role of subject and the writer to the role of main character/keeper of records. Neal's attempt at living up to Kerouac's caricature might have contributed, in some way, to his final flaming out. In the following bit from *Visions of Cody*, Kerouac—as Jack Duluoz—voices the boredom and anxiety caused by living his life as an entertainer, realizing that he's really only doing it to entertain himself:

> *All kinds of things like that were occurring to me in the finalities of the peyotl day. "Well," I say to Cody, "and so you are Cody Pomeray" (saying this to myself) and out loud to him: "Well so there you are sitting there." I felt like a portrait artist; I felt like he was a ghost I'd come to see, which is exactly what he was when I left New York to come here.*

The Beats were known to experiment with illegal substances, from the psychedelic cactus previously referenced to marijuana. Despite having once said, "War will be impossible when marijuana becomes legal," and his lifelong overindulgence (even unto death) in hard liquor, Kerouac was later to regret any role he might have played in influencing kids into the use of "harder drugs" through their enthusiastic portrayals in his writing. Neal traded two sticks of pot to two narcs for a ride home from work at the railroad one afternoon in 1958. The agents in question knew that Neal was the inspiration for the character from *On the Road* who'd come to symbolize nonconformity—it was a setup—and he ended up serving a few

years in San Quentin. Neal's pot bust occurred during a time when he was endeavoring extremely hard to live the role of *paterfamilias* to his wife and three children while employed as a brakeman on the SP San Diego Railroad, making him an early martyr for the cause of sensible cannabis laws in the United States.

Tortured actor James Byron Dean prefigured Dean Moriarty in the American consciousness as a magical Superhero of Cool come to whisk them away from their dreary suburban-minded lives and was caricatured twenty years later by the Fonz on *Happy Days* shrugging at a flawless reflection in Arnold's bathroom and deciding not to comb his D.A. after all. After topping the charts as a Denver car thief and, in time, becoming the living archetype of one of America's greatest cultural transformations to date by dint of sheer style, Neal Cassady was discovered shirtless and dead from exposure on the railroad tracks in Sam Miguel de Allende, Mexico, in February 1969. According to journalist Robert Stone, who hid out with the Pranksters in Manzanilla before Cassady's death and wrote about it in his memoir, *Prime Green*, during this period Neal did not eat, sleep or stop talking and was known for slipping LSD into unattended drinks. Cassady never took to acid, preferring amphetamine stimulants to overenhance his overzealous talking-thinking jags and, toward the very end, the dissolution of barbiturates to sift his crowded mind. According to Stone, Neal trained his parrot, Rubiaco, to do an impression of his own high octane, herky-jerky word switching so perfect that, twenty-five years after Cassady's supposed death, Stone and his wife, Janice, were startled to hear Neal's voice up in the trees outside on Kesey's farm one morning—"Fuckin' Denver cops. They got a grand theft auto. I tell them that ain't my beef"—sending them bolt upright out of the sheets. As someone committed to extreme behavior, Neal is reported to have been using barbiturates heavily at the time of his death, which no doubt contributed to the extremes he was able to reach (including, apocryphally, setting out to count the number of railroad tracks between a few Mexican towns—his last words are fabled to have been "47,298").

Years later, William S. Burroughs, who never liked Cassady much, developed a successful method of sabotaging people and institutions (for example, one called the Moka Bar in London, for "unprovoked discourtesy and poisonous cheesecake") based solely on playing back recordings of previous sounds from that location. Burroughs had a fondness for unconventional ideas, but this one, when applied to the eventual dissolution of Neal and Jack's bond, bears consideration. The two men's

disunity became undeniable with Jack's less than approving reaction to the Merry Pranksters' promotion of the consciousness-expanding drug LSD: "Walking on water wasn't built in a day." To have value, things must be earned and deserved, he seemed to be saying. You can't just make them happen at will. Jack's refutation of "turning on" enlightenment, as the Merry Pranksters were trying to do, was in direct contradiction to his long-professed admiration of Neal's turgid heart, in tribute to which he'd gone so far as to inaugurate a whole new prose style. Neal was a living independent self, grown boldly past the confines of Jack's book and forsaking his maker's authority, just like Frankenstein's monster.

Denver Beats in the '60s and '70s

Many West Coast cities besides San Francisco, including Venice Beach (as chronicled in Lawrence Lipton's *The Holy Barbarians*), hosted thriving Beat communities throughout the '60s. The two scenes were mutually supportive—"We're just the older ones," said Kerouac—and Denver Beats took part in the mass migration of thousands of sunny-eyed youth to Haight-Ashbury and the rest of Wonderlandifornia. While the Beats were undeniably a causal influence on the Hippies, the flower children seemed naïvely idealistic to hardliners, despite Ginsberg's earnest efforts to include himself in their pageantry. When Hippies supplanted Beats as the popular representation of American outsiders in the 1960s, some Beats were resentful of what they saw as the dumbing down of their earnest contrariness to cultural norms.

A writer of all sorts since age fourteen, Philadelphia native and longtime Denver resident Edwin Forrest Ward made a name for himself as a poetry and storytelling host at Denver's Mercury Café for two or three decades. Before any of this, he was an instrumental figure in the '70s Denver Beat scene. "I don't even like the term 'Beat' as a definition; I prefer 'Bohemian,'" said Ed. "Artists are just themselves." Ward's Passion Press was the first to publish Kerouac's letter praising Neal to Ed White without the names being blacked out (similar letters were published previously, with names redacted, in Larry Lake's *Mano-Mano 2*), after Ed befriended White and convinced him that everyone knew who he was talking about anyway.

Ward was hosting a reading at the Casual Lounge on Floyd and Broadway in Englewood when Larry Lake took the stage. Lake proceeded to spread his

published works on the table and smoke two slow cigarettes before saying a word. "I'm the only fuckin' poet in here," he growled finally, "none of you has a clue," before launching into an abusive rant directed toward the audience and walking offstage after delivering a world-class reading.

When the next reading rolled around, Ward was ready. "When Larry's name was called, he went into the same routine, started smoking that cigarette. Then when he went into his rant, I stood up on a table at the back of the room and started reciting this poem I'd written called 'Larry's Lake Is Leaking.' Lake gathered up his poems, left the stage and walked away."

In 1978, during a visit to Venice Beach, California, Ed was reacquainted with Lake, and the two became best friends over the years, sharing publication in a number of the same magazines and patronizing and hosting readings at a number of Denver establishments, including Café Nepenthes and an all-night coffeehouse at 14th and Market Streets downtown, featuring readings by Denver Beats Larry Lake and Tony Scibella and William S. "Billy" Burroughs Jr., son of *Naked Lunch*, who lived in Denver shortly before his death.

Poet Tony Scibella is a '50s/'60s/'70s/'80s/'90s Beat with strong Denver connections. His *The Kid in America*, which Ward said is "better than anything Neal Cassady ever wrote," took twenty-four years to write and was completed after a long hiatus thanks to inspiration from another Denver poet, Kate Makkai, to whom Scibella dedicated the opus upon its publication by Passion Press/Black Ace Books in the year 2000. "Tony used his own spellings for certain words, like the word 'bright' would be spelled b-r-i-t-e," said Ward. "Stuart Perkoff's Venice West Café Expresso, one of America's first Beat establishments, sported Tony Scibella's misspelled 'Expresso' logo. People thought he was trying to be hip." Beat scholars may never have heard the name Tony Scibella, but despite his lack of popularity in comparison to the movement's superstars (who differed in that they—Allen Ginsberg especially—went after publicity eagerly), copies of his books, including *The Kid in America*, are available at Amazon.com. Scibella's children were raised mostly in Denver, and Denver became Scibella's second home after Los Angeles.

Stuart Z. Perkoff, author of *Eat the Earth, Only Just Above the Ground* and several other books, is another "second wave Beat" with Denver links. His collected work, *Voices of the Lady*, was published by the National Poetry Foundation in 1998. Perkoff appears in a clip from Groucho Marx's *What's My Line?* featured in Chuck Workman's 1999 documentary about the Beats, *The Source*. When Groucho asks him if he's some kind of writer, Stuart's quip about writing home for money all the time makes the noted master of one-

The Denver Beat Scene

Neal Cassady is top center in this detail from the collage of Colorado notables by Barbara Jo Revell at the Colorado Convention Center. *Photo by Michael Scalisi.*

upmanship's jaw drop to be one-upped right off the bat by a total stranger. "And it kept on happening, all through the interview," said Ward, who became friendly with Perkoff during their time together in Denver, Venice Beach and San Francisco. "Groucho loved it," added Ward, who came to know the work of Perkoff through his friendship with Lake and Scibella.

Scibella and Perkoff had walked the Venice boardwalk together in 1959, along with Frank T. Rios; all three are considered among the best poets to come out of the Los Angeles area. Their work can be found on three of the "Poetry Walls" dotting Venice Beach today. When Perkoff was released from a California prison in the early '70s, he came to Denver at the invitation of Tony Scibella, who ran the Ogden Bookstore on Colfax Avenue. While in Denver, Perkoff's work was published by James Ryan Morris's Croupier Press, Tony Scibella's Black Ace Books and Larry Lake's Bowery Press.

Morris's Black Smith Books (named in homage to poet, editor and founder of the American small press movement Harry Smith) was a bookstore formerly located at 429 East 17th. "I always thought it was called Croupier

The Mile-High Legacy of Kerouac, Cassady & Ginsberg

Close-up of writer and publisher Jimmy Morris (center), from the collage of notables by Barbara Jo Revell at the Colorado Convention Center. *Photo by Michael Scalisi.*

Books," said Ed, "because that was the name of his press." Both Scibella's and Lake's presses and bookstores shared the same names. Morris, a writer, café owner and publisher whose approval among underground artists was once highly prized, was also a Korean War veteran with a skull-shaped belt buckle and a penchant for firearms. He is among the Denver notables (including Neal Cassady and author/filmmaker Stan Brakhage, one of the first participants in Denver's Trident Theatre on Gaylord—the only avant-garde theater in town in the '60s, according to Ed) whose faces are pictured in Barbara Jo Revell's collage at the Colorado Convention Center.

When the slam poetry movement hit Denver in the early '90s, I was present at a debate between pro and con factions in the Denver poetry scene at City Spirit Café (since closed) on 14th and Blake. Late Denver poet Woody Hildebrand produced a papal edict from the eleventh century forbidding competition in the arts. I remember my skepticism about said edict's validity at the time, although I have since come to full agreement with its precepts. I spent a few years trying to fit my own style of expression into the slam motif until it felt too small. I was satisfyingly inspired by my years trying to be a

The Denver Beat Scene

Close-up of filmmaker Stan Brakhage from the collage of notables by Barbara Jo Revell at the Colorado Convention Center. *Photo by Michael Scalisi.*

Plaque honoring Jack Kerouac's *On the Road*. *Photo by Michael Scalisi.*

slam poet. It fit right in with the Henry Alarmclock routine, after all. But it felt more like playing a board game than having an adventure.

Throughout my encounter with Ed, I remained mostly silent, understanding that this was my chance to be a receptacle for privileged information. After our interview concluded, we went to Village Inn in my new neighborhood of southeast Denver and talked about being a good host. It's a natural instinct in writers who feel full of fire to express their emotions dramatically, but when you're preaching to the choir, a confrontational approach can fail and fall hard like a ton of bricks, infecting the communal atmosphere with ego burn, bringing everyone down. A good host of poetry events has to balance those poles, encourage and prune at the same time, like a gardener.

"With great power comes great responsibility."

"Yeah."

I can't remember who said what. We were of one mind.

A sad note from local Beat history in closing: Shortly after the advent of the light-rail mass transit system in Denver, poet Alfred Dietrich Kleyhauer III (whose work was published by Alan Swallow of Swallow Press, known for publishing Henry Miller and Anais Nin) was struck down and killed by one of these on 15th and California on October 25, 1994, just near the golden stamps in the sidewalk honoring Cassady, Kerouac and others.

BILLY BURROUGHS AND ED WARD

The Beat Generation's discernable influence on U.S. culture seemed to extinguish itself with the passing out of fashion of the 1960s "Love Generation" that followed its liberated example. But Denver enterprises like poet Tony Scibella's Ogden Books at Colfax and Ogden, for years a prime Beat lit outpost, and poet Larry Lake's Bowery Gallery at 15th and Platte (catty-corner from My Brother's Bar, formerly Paul's Place)—both establishments out of business these days—have provided clear evidence of the movement's lasting effect in Denver. Besides these examples, who can say how many aspiring writers followed its collective example at open mic readings all over the country, writing spontaneously per Kerouac's example, per Ginsberg's, per Corso's and so on. I was one of several such in Denver alone. Ed Ward has retired from the position of Mercury poetry host and currently hosts a monthly event at the same venue called "STORIES STORIES," arranging a menu of quality presentations in that form from local and visiting authors of note as one living example of Denver's connection to the Beats.

William Burroughs Sr. never adopted the classification "Beat" for himself but was arguably every bit as influential on their collective spirit as was Cassady, although in a more cerebral, less emotive way. By contrast, Old Bull's son, Billy, seemed, in a near-literal sense, born to wear the mantle of countercultural infamy, as exemplified by his two finished works, *Speed* and *Kentucky Ham*. A third book, *Cursed from Birth: The Short Unhappy Life of William S. Burroughs Jr.*, edited by *Motorman* author David Ohle at the invitation of Billy's father, is more a compilation of aftereffects than a serious literary

production. Billy Burroughs had contracted to write a third novel called *Prakriti Junction*, but his death from a liver transplant failure due to heavy drinking interposed. *Cursed from Birth* is his notes on that unfinished project, spliced together with selections from his published works and postmortem aftereffects, plus commentary from witnesses of his tragic decline and demise at thirty-four. Near the end of his life, Billy spent a lot of time in Boulder and Denver, at one point tentatively giving lectures at the Kerouac School and drinking heavily despite the transplanted liver, which he'd begun referring to as "my new wife," having learned its donor was female:

> *As for rejection, there was very little difficulty. I immediately began to feel and say that Virginia and I had grown very attached to each other and were working out compromises. I could smoke and cuss if I let her brush my teeth—she took control of my left hand. I thought of it as a marriage of sorts. These were the beginnings of something so strange that the doctors didn't even want to discuss it.*

Although written in full consciousness of impending death—liver transplant recipients under ideal conditions were given six or seven years to live at the time of its creation—*Prakriti Junction*, as presented in *Cursed from Birth*, retains Billy's characteristic witty tang, if especially mordant:

> *I live in a one-room apartment in Denver now (two blocks from hospital where they piece people together from parts of other people and make the party of the second part a coffin for the party of the first part). The plumbing is backing up and there's a terrible odor. The kitchen is small and I have on the stove a small frying pan half full of canned ravioli. In the clean bathroom sits a flowerpot containing an upright twig of dried blue flowers and from the ceiling hangs an empty snuff tin on a string—strictly Zen.*

Billy Burroughs's reputation as a writer is unfortunately eclipsed by the extent of his father's fame as the author of *Naked Lunch*. After William Burroughs Sr. shot his wife, Joan Vollmer Burroughs, in a drunken game of William Tell, his son, William Jr. (Billy), was sent to live with his grandparents in Florida and was separated from his father for most of his formative years. After becoming addicted to speed as a teen in the late 1960s, he went to Lexington, Kentucky, for rehab and then to Alaska as part of an experimental school's therapeutic expedition. His *Speed* is a smartly worded, extremely readable novel about psychic frontiers from the horse's mouth.

The Denver Beat Scene

Billy embarks on a hallucinatory voyage from his grandparents' mansion in Florida to bomb around New York City like a drug-addicted Holden Caulfield in search of some ultimate reality in which to play goalie. *Kentucky Ham* is great in places, too, picking up from Billy's return to Florida and covering his time in rehab and his trip to Alaska. It begins really well but suffers slightly from the imposition of a "diary entry" style toward the end. Much of Burroughs's work has been lost due to his haphazard manner of living. Said Ed Ward, "His best work was published in *New Blood*, a 1970s Boulder-Denver magazine published by Michael Wolczuk."

Irrevocably imprinted by the allegedly accidental shooting of his mother by his father—according to Billy, in his presence, although Burroughs Sr. denied it—Billy's relationship with his father was by turns loving, hateful, respectful, afraid, sad and so forth, as might be expected. This is evident in many passages from his books, like the following from *Cursed from Birth*:

> *I went to see my father for four hours. We had a fine Chinese dinner. I asked him, "What if, at a point, the pressure gets to be too much?" I was desperate. He smiled a little somehow, and said: "Well, heh heh, some of us make it and some of us don't." When we got back to his place he went to bed early because he had a plane to catch the next day, and I don't see the old flub for another year. I had hoped we would spend most of the afternoon just strolling the Mall and taking in the sights—but before I hardly wiped the sleep from my eyes, Allen and I loaded up the trunk of the car and he was gone.*

Billy's was the first story I came across as a Beat fan that felt current. After this he discovered Jan Kerouac's *Baby Driver* and the works of Jim Carroll, who united the Beat scene with punk, both of which were also more contemporary links in the chain. Reading the opening paragraph of *Speed*, which he'd just purchased at the Tattered Cover in Cherry Creek, aged fifteen or sixteen, your reporter recognized its excellence immediately:

> *For ten years, I lived on a street lined with royal palm trees at the north end of Palm Beach where the houses get smaller and some of them have no servants. For nine years, our house had been just as manicured as the next, but when my grandfather died, we let the roof get a little grey and the two banyans in the back yard took each other in their arms and, weeping, filled with spider webs.*

Billy's Denver experience was primarily a solitary one, during which he wrote a number of letters to people and organizations he felt might provide

an escape from a state he considered to be "not much of a picnic," including the writer Charles Bukowski, at the time famous because of his poetry, and the World Spiritual Association, an outpost of Spiritualism in Cassadega, Florida. No one responded to Billy's entreaties, and it was during this time that he began to consider himself perhaps fatally cursed by his *Prakriti* (a Hindu word meaning "station in life") due to given circumstances. He had a habit of "burning down" or expending certain potentially beneficial connections. At one point, Ken Kesey invited him to his Oregon farm in support of his recovery, but Billy pulled out, fearing that he might "freak out" Kesey, who struck him as genuinely normal and sound-minded compared to himself.

Billy's apartment in the Oxford Arms at 765 South Colorado Boulevard, since replaced by the parking lot of a popular grocery franchise, was no. 16. While staying there, Burroughs Jr. developed the habit of dumpster diving, still popular among Denver dropouts and creatives, although in Billy's case it seemed to have greater occult meaning akin to following a trail of magic trinkets through an urban wasteland. Said Anne Waldman of her friend's son's scavenging, "Billy came in and put things on the walls, pictures he cut out of magazines and newspapers. He brought in found objects, talismans. Lots of Tchothchkes and things he found in the trash…He had no heritage or heirlooms…They were emblematic signals and signs from a world that meant something."

A note from Billy on the nuts and bolts of scavenging:

> *As I was rooting through a bin with my metal rooting rod, an old lady came out of her house with bags containing, among other things, a fine, fine jacket, a sweater, and a pair of wearable shoes. She said, "I'm sure someone will find these" (meaning me). She smiled and walked away. I said, "You know something; you're an awfully nice person." As I was leaving, she said, "Would you like to come in for a minute?" I said, "No ma'am (shuffle, shuffle) I makes it a practice to don't never impose."*

Billy made periodic contact with the Denver literary and bohemian scenes through the auspices of his godfather, Allen Ginsberg, showing up at a public reading like the one hosted by Ed Ward at Café Nepenthes. In a piece called "Billy Burroughs' Prediction," Ward recounted an encounter with Billy and Ginsberg in Larry Lake's Bowery Books on Old South Pearl beside a sensory deprivation joint called Float to Relax (both since closed), and a friendship between the two writers developed: "Over the course of the next year or so I pursue a friendship with the creature that is Billy Burroughs. I say creature,

The Denver Beat Scene

because not unlike Frankenstein, Billy B, he's come back from the dead. Another's liver keeps him alive, that of a woman named Virginia whose brain failed at about the same time that Billy's original liver did." Ward recounted the "junkie's intuition" that led Billy to bond with fellow reader/writer/junkie Larry Lake, as well as the decidedly eerie way he discerned Ed's wife Marcia's pregnancy at his thirty-third birthday party when no one else, not even she, had any clue:

> *Billy sighs, smiles, and rephrases his request. "When are you going to tell us about the baby?" Somewhat alarmed, yet with a mixture of naughty delight and hopeful anticipation, while simultaneously defensive, Marcia soundly refutes the thrust of Billy's innuendo. "I most certainly am not pregnant." Billy sighs again, smiles again, and adds, "Ah yes, so you think, but nonetheless, you are. I would never kid about something like this. Being pregnant is not funny. Believe me. You are going to have a baby."*

Billy's grandmother Laura Lee Burroughs was known to be on speaking terms with spirits, and Burroughs Sr. was a lucid spokesman for the benefits of astral travel, so the prescience Billy displayed on this occasion may well have been hereditary. In 1981, Burroughs stopped taking his anti-rejection drugs. Allen Ginsberg was notified that Billy had returned to Florida to reconnect with the founder of the Green Valley School, during which impulsive visit he was found lying chilled, drunk and exhausted in a shallow ditch at the side of a DeLand, Florida highway on March 2. He was pronounced dead the following day of acute gastrointestinal hemorrhage associated with micronodular cirrhosis. The author "Miles," who wrote a book on W.S. Burroughs called *El Hombre Invisible: A Portrait of William S. Burroughs*, noted:

> *Although Billy had been separated from his wife for many years, she took charge of his remains. She blamed Bill for his son's self-destructiveness and did not want him to have his son's ashes. Instead, she sent them to Allen Ginsberg for disposal [who] organized a Tibetan Buddhism ceremony at the Rocky Mountain Dharma Center. He took the ashes to the Karma Dzong shrine room at Naropa and placed them on the altar, where they remained for the traditional 49-day purification period. On 3 May, Billy's ashes were scattered at Marpa Point, on the mountain high above the Dharma Center. Billy's father did not attend the ceremony...He and Billy had never been able to have an honest, face-to-face conversation, even in the face of death.*

BLOODLINES

Denver Beat historian Mark Bliesener organizes the annual Neal Cassady Birthday Bash, held annually every February 8 at the Mercury Café in Denver. Both of Neal's daughters, with Carolyn, Jami and Cathy, attend the bash nearly every time, as has Neal and Jack's collaborator, David Amram. The Cassady family's assistance in the production of Heather Dalton's independent film, *Neal Cassady: The Denver Years*, has been crucial, and their goodwill toward the production of this volume is greatly appreciated.

Named in honor of his father's two best friends, Jean (John) Louis Lebris de Kerouac and Allen Ginsberg, Neal and Carolyn's son John Allen Cassady is a writer and musician. He has also been a regular attendee of the Birthday Bash series. John traveled in the Beat Museum on Wheels with Beat Museum owner Jerry Cimino—with a multimedia show that incorporates video, slides, poetry readings, music and storytelling—to share the story of the Beats with colleges and universities. His website gives ample evidence of his creative talent. After more than twenty years as a computer engineer in Silicon Valley, he is writing a book about his father.

The Beats were every bit as nonconformist in the area of relationships as they were in matters of the spirit and prose technique. Neal fathered a few (known) offspring besides his three children with Carolyn. In August 1949, Jack Kerouac introduced Diana Hansen, a young model, to Neal—who was still married to Carolyn and had been running around with Lu Anne again—at a gallery opening in New York.

Art from *Neal Cassady: The Denver Years*. Courtesy of Daniel Crosier and Karl Christian Krumpholz.

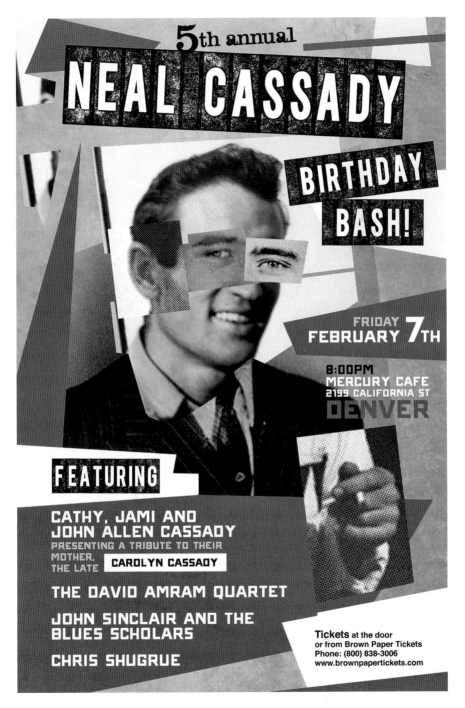

Promotional poster for the fifth annual Neal Cassady Birthday Bash at the Mercury Café. *Courtesy of Matt Bargell of NORDEN41.*

On January 26, 1950, while Neal was in New York with Diana, Carolyn gave birth in California to Neal's second daughter, Jami. In February 1950, Neal got Diana Hansen pregnant and for a time maintained relationships with her and Carolyn simultaneously. In a 1950 letter to Ms. Hansen from San Francisco archived in *Collected Letters, 1944–1967*, he wrote:

> *All my best wishes for an easy confinement. May the good doctors excel themselves—including admission—and make the little bastard pop right out. It's not too easy a thing to be the father of a bastard, but, since it's much harder to be the mother of one, I take this opportunity to tell you my regrets, sympathies and apologies are in order and proffered with an enthusiastic promise to try once again to lift this dreary old weary fart up by the bootstraps & make a most honest effort to help you live happier in the days ahead.*

To ensure the child's "legitimacy," Neal drove with Jack to Mexico to get a quickie divorce from Carolyn, marrying Diana on July 10 in New York and then heading back to California and an irate Carolyn several days later. On November 7, 1950, Diana gave birth to a son, initially named Neal III but later changed to Curtis, perhaps in honor of the Denver pool hall street. By this time, Neal was back, more or less permanently, with Carolyn, Cathy and the infant Jami. Diana attempted to adjust to the somewhat unconventional arrangement that Neal was apparently trying to arrange, and to judge by his letters to Diana, he appears to have done his level best with child support for a period.

Curtis Hansen passed away in April 2014. From his obituary at the Connecticut-based website ctpost.com: "Born and raised in New York City he was the son of the late Neal Cassady and Diana Hansen. He attended Northfield Mt. Hermon School in Massachusetts. Curt was a 1974 Cum Laude graduate of Boston University and in 2006, he earned an MBA from the University of New Haven." In 1983, Curt Hansen co-founded and launched what rapidly became the top radio station in Bridgeport, New Haven and Fairfield County, Connecticut, with an emphasis on community service and a menu of adult contemporary music.

Although he acknowledged her parentage privately, Jack Kerouac's daughter, Jan, author of the novels *Baby Driver*, *Trainsong* and *Parrot Fever*, grew up without financial support from her father and had to fight most of her adult life for public recognition of their blood relationship. It is believed that her mother, Gabrielle, known colloquially as "Memere," was opposed to

Jack admitting parentage. Jan Kerouac died in Albuquerque, New Mexico, on June 5, 1996, one day after her spleen was removed after suffering kidney failure. Gerald Nicosia, who at one time was Jan Kerouac's personal literary representative, has edited and published a book of tributes to her entitled *Jan Kerouac: A Life in Memory*. William S. Burroughs Jr., or "Billy," lived a short, unhappy life that resulted in two novels and a postmortem compilation of works in progress. Allen Ginsberg never had children. During the early 1960s, Gregory Corso married an English teacher named Sally November, who grew up in Cleveland, Ohio, the union of which resulted in the birth of his daughter Miranda. Corso married two other times and had sons and a daughter from these engagements.

THE HYATTS

Upon learning the unfortunate news of Curtis Hansen's passing, your reporter forwarded this information to Neal's eldest known living son, Bob Hyatt, currently sixty-nine years old and living in Arvada. "I would have liked to have met him," said Bob. "There's no way of knowing how many of us there are. He was so prolific."

Sex education in the early 1940s recommended abstinence for youth, bolstered by fear of sin and plague. In a sense, the Beat Generation took promiscuity as far as it seemed to want to go despite these proscriptions, and many suffered when this frantic freedom fell out of step with ethical requirements like unexpected children. Promiscuous Neal may have any number of offspring unaware of their parentage. I assumed that I had probably opened a door on the pool hall or East High scenes when Denver poet and storyteller Ed Ward put me in touch with Mr. Hyatt, but Bob's mother had passed away by the time he learned her name. And his parents' ages were listed as nineteen and twenty years old by the confidential intermediary assigned to the adoption case by the Denver Juvenile Court, who investigated and interacted between adoptee and biological families long past high school age. Bob Hyatt was given up for adoption by his mother, who came from the town of Montrose southwest of Denver, and was adopted when two weeks old. He learned the word *adoption* in school at age seven, and when he came home, he asked his adoptive mother, "Am I adopted?" She admitted that he was.

In 2011, at age sixty-six, already having learned about his true maternal background, Hyatt decided to find out the identity of his biological father.

After obtaining the records, he noticed that all the spaces for the last known address, place of employment and so on for his birth father (listed as "Neil Leon Cassidy") were marked "unknown." "I don't think she knew him very well, to say the least," he noted.

Bob did a number of searches on genealogy websites with little success. A friend suggested that he try a simple Google search, and a Denver connection appeared right away. A little investigation revealed his father's unexpected identity as a paragon of countercultural transformation who inspired the fervent hero of the Kerouac book that had contributed to Bob's own wild road.

"Did it feel like a surprise or a reward?" gushed your reporter immoderately, attempting to empathize with that unimaginable perspective somehow.

"It did," Hyatt allowed. "I first met the Cassadys through Heather Dalton. I met her and told her my story, and she was very helpful and friendly. A little suspicious, and understandably so. So, I offered to show her the records. She put me in touch with the Cassadys, who were very friendly and welcoming, which was nice. I stayed at Cathy's house for almost a week. She seemed to have lived a relatively straight, conformist life. She is well educated and worked in the healthcare industry before retiring."

We met at Zorba's Café on 12th and Clayton. Waiting for Mr. Hyatt to arrive and knowing only to expect a white ball cap with "08" on the front, I sat anticipating brash shoulders bursting in at the café door. On the contrary, when he arrived, Bob's appearance surprised with its unprepossessing composure. Clad in a white T-shirt, jeans, sneakers and the promised ball cap, he wore glasses and had gray hair. The family resemblance became apparent once he sat down, something in the shape of his face and a habit of emphasizing his speech with illustrative gestures recalling Neal's in footage of a conversation with Allen Ginsberg at City Lights Books in 1965. "All forms are known," Cassady says at one point in that clip. "Life goes where the new forms are."

Bob never read a Kerouac biography nor had any idea that Dean Moriarty was other than fictional before learning Neal was his father. He read *On the Road* when he was in high school and was inspired by it like other young men of his generation, but he put it aside. "I didn't read a lot in those days because I was more interested in engaging the real world. I must have inherited some of Neal's nonconformist spirit, though, as I had a rather reckless youth."

Something else Bob inherited unknowingly from Neal was an aptitude for the game of pool. Retired from a career of teaching fine arts, he's a member of two competitive pool leagues. All of this by natural instinct.

The Denver Beat Scene

Robert Hyatt. *Courtesy of Robert Hyatt.*

I commiserated with fellow searcher Bob about the few good books about Neal's life in Denver. "Lu Anne's book is very good. Lu Anne Henderson, Neal's first wife, that's called *One and Only*, an interview with her by Gerald Nicosia, who wrote a biography of Kerouac called *Memory Babe*. And Carolyn's book is also very good. It's called *Off the Road*."

Hyatt wrote down those names and volunteered that, prior to his awareness of any connection to Neal Cassady, a friend's troubled son had been referred to Justin Brierly for guidance. "Yeah, he was known for that."

Bob Hyatt has worked as a freelance artist, teacher, counselor and human services administrator during his career. He's an extremely accomplished painter influenced by French Impressionism, Northwest coast Native American (Indian) sculpture and painting, Russian Constructivism and more, as well as capable in a gamut of styles, including American Abstract Expressionism, Art Deco, Minimalism Sculpture and Op Art. Bob has an aversion to public speaking but will occasionally do so, and I recently learned that the canny piece about schoolyard politics that his thirty-year-old daughter, Vera Elizabeth, read at Ed Ward's "STORIES STORIES" event at the Mercury Café several months before had, in fact, been written by him. "Yes, I've written down some of my early experiences."

Vera read again at the latest installment of "STORIES STORIES." Sharing a table with her, Bob and Bob's son, Henry, I was struck by the uncanny resemblance of all three Hyatts to pictures of Neal that I'd seen over the years in various books. The piece Vera read was called "My Wanderlust Condition," a beautifully crafted exposition of the itinerant lifestyle that she's chosen as an inherent need:

The Mile-High Legacy of Kerouac, Cassady & Ginsberg

Neal's granddaughter Vera Hyatt at a tea ceremony. *Courtesy of Vera Hyatt.*

About this Wanderlust way...It's the kind that, best not to start. And if you do start, better to finish.

Here's why:

A few years ago, after one of the several month stints out in the wilds of the world, feeling determined to return to Colorado to stay put and "build" something and/or "settle" somewhere...I realized in a short time by way of a creeping, sinking feeling that...maybe...

I can't.

In this piece and others (posted at her blog, www.shesgotthatwanderlust.com), Vera hopes to help people with pressures of wanderlust, inspiring them to choose a life that makes for a good story and to use their fully expressed voice to share it.

At some point during my wanderlust journey, I was inspired to begin documenting it. I have been interviewing people I meet on the road via digital audio and video recording. The main theme of the interviews is, of course, based around my primary question in life at this moment: What is Home? There are also strong elements of the importance of creative self-expression (art, music, stories), choosing one's life work (or being chosen by it), love and relationships (monogamy, marriage), the meaning of life in general (or the lack thereof)—all in the context of living on the road or, in some cases, juxtaposed to it. I'm fascinated by people and their journeys through the thick absurdity and heartbreaking beauty of this "One precious life"!

Elsewhere in "My Wanderlust Condition," she estimated that her stay in Colorado will last about six weeks, but an addendum to the site's mission statement implies that she might stand still long enough to assemble and upload some video shorts—"The soundtrack will be my message in the voices of other people," she said. "You'll see…."

Henry Hyatt, twenty-four, Bob's son and Vera's brother, although not professionally trained, is capable of impressive feats of balance, as evidenced by a few shots on his Facebook page showing him standing on his head and hands or holding his body parallel to the ground with one arm. "I prefer to describe it as a certain absence of imagination on my part," he said. "I never thought about what might happen if I *couldn't* do it. But I've been that way for kind of my whole lifetime—get into something, tunnel vision onto it before I consider the peripherals. When I was fifteen, I woke up one morning and decided I could do a standing backflip. I just went out on the lawn, it took me like four or five tries." Henry is also a martial arts champion.

Vera agreed that the 1965 footage of Allen and Neal at City Lights is reminiscent of her father and especially her brother. "It blows my mind, makes me feel a little bit antsy or something. Your use of the words, intonation and tone, even the way you move. It's creepy."

"Yeah, it creeps me out, too," agreed Henry. "Like an out-of-body experience."

Henry had recently returned to Denver following time spent living in the New Age capital of Sedona, Arizona. "A lot of people go there and dread up their Anglo hair and change their names, but all they're doing is changing their aesthetic. My friends and I made up names for ourselves as a joke. Me, because I'm from Denver, my name was Butterfly Pavilion."

The Mile-High Legacy of Kerouac, Cassady & Ginsberg

Henry Hyatt. *Courtesy of Henry Hyatt.*

He's been casually pursuing writing for a number of years, with a feeling of "words piling up in the hopper, tripping over each other." When he discovered his connection to Neal, Henry said it explained his lifelong sense of disconnection from conventional society, but he hasn't read any of the biographies, preferring to pick up details in conversation with historians like myself. "I read *On the Road* before I knew we were related," he said. "When I read it again after finding out, it had a different impact. You gave me that one." Henry looked at his ever-traveling sister, who nodded. I felt caught in a vortex of timeless, wise purpose for a second.

Bob's two other children are both as interesting and different as Vera and Henry.

Heather, Bob's firstborn (in 1968, with his first wife, Kris), is the director of the Infantile Scoliosis Outreach Program and a businesswoman (having designed, fabricated and sold equipment used in treating infants with extreme and life-threatening scoliosis). Heather has a sixteen-year-old daughter, a very bright and strong young woman who has suffered from scoliosis her entire life.

Bob's second wife, Sally, is the mother of the other three children. His daughter, April, born in 1986, lives with her fiancé in Nicaragua, where they run a holistic-style restaurant, spa and exercise center employing about twenty-five staff. She is the singer in a band that just recorded a demo. Before leaving Colorado, she was the state champion of a martial arts discipline (grappling) for two years in a row.

"Was Neal Cassady left-handed?" Henry wanted to know, when I interviewed him and his sister at Hooked on Colfax coffeehouse. "I have a thing about left-handedness. I had a group of friends in high school, three out of five of whom, including myself, were left handed."

"I think so. I think there's a passage in *On the Road* where Kerouac says Dean is a southpaw. I'll find out for you."

We talked about Neal's status as a martyr for pot smokers via his setup and bust in 1958 and resulting imprisonment for a few years in San Quentin. Neal's propensity for love of T is well known among readers of Jack's books. He called it "Elitch" along with Jack and Ed White, and Ginsberg forwarded his frequent demands for "more oolong tea" to Bill Burroughs's Texas ranch. Medical and recreational cannabis use has been legalized in Denver, Colorado. The resulting financial surplus has far exceeded the state's expectations, and legalization of cannabis in one form or another shows every sign of an unstoppable national trend. Consumers have remarked that they greatly appreciate the convenience of the legal cannabis model, not without a vague concern that the whole thing's lost its rebel spirit somehow. Regarding these developments, Vera said, "I wonder how he'd feel, if Neal were here today. I don't think he would have liked it. The legalization, I mean."

"I'd like to think that Neal's perspective on things is irrespective of anyone else's," commented Henry.

"Yeah, he didn't get hooked into things," she agreed.

This reminds of Neal's obliviousness to the racial tension encountered by Jack and Lu Anne in the California jazz club and his multiple joyrides in stolen cars all over his teen Denver, seemingly driven by a love of experience to take outlandish chances and often succeeding, a super-sizing of the games he played bouncing that ball through Five Points on his way to grade school.

Said Vera, "I question, a lot of times, this wanderlust—the genetic thing. There's actually a gene that they've isolated now called the nomad gene that causes people to run around. I found out about Neal almost a year after my wanderlust really set in on a physical manifested/lifestyle level."

Beat fans will think of Dean Moriarty's notorious cross-country zigzags for precedent here, but unlike her grandfather, who struggled to balance

his compulsions to "Go!" with home life and a railroad career, chosen largely for its mobile nature—trying to have it both ways at once—Vera has apparently made peace with her own drive, having established a comfortable life of constant motion in the hobo jet set after cashing in the profits from former years as the owner of two successful bakeries, Venus Bakes and Le Rêve Patisserie. "STORIES STORIES" had an anticipatory quality that night. Heather Dalton's *Neal Cassady: The Denver Years* was screening at Sie Film Center on Colfax in two days. Ed Ward announced it from the stage and was kind enough to allow me a moment on mic to promote the Beat Generation Landmarks limo tour, my own latest odd job.

For the past several months, I've been hosting a variety show at Mutiny Information Café in Denver with mixed success, and Henry and Vera Hyatt attended one of these after we met. During another attendee's banjo performance of "Under the Milky Way Tonight," your reporter rifled through his much dog-eared copy of *Cassady's Collected Letters, 1944–1967* for the southpaw quote to share with Henry Hyatt but was unable to locate it.

Vera was the final reader, delivering a piece from her blog about the "Community Haircut" she received from sixteen people collectively some

Mural at Mutiny Information Café. *Photo by Michael Scalisi.*

Mutiny Information Café. *Photo by Michael Scalisi.*

time ago, each barber allowed to make three cuts of absolutely any length and style, a concept akin to her movie—other voices telling her own story. Later the same night, Henry Hyatt impressed all comers with his tactical

aptitude as a writer of fiction, as seen in this bit from "A Thousand Light Years of Lead," part of an ongoing work written about his own life as it happens. An excerpt follows:

> *Joe forgot his beanie, the one that Stefie made. I still haven't mailed it to him. Joe's absence pushed me to wonder what gave me the fuel to survive this chapter. And what was I recovering from? Was it from drugs; either the street kind or the doctor kind? Or from the lens of my own eye, and the subsequent shell-shock of abrupt disillusion? Or something else? I don't know. No answers. And so, back in the truck. Gassing and clutch. Shift gears. For Denver. For home. When will I make it to Seattle? All I am is a ghost driving a meat-wrapped skeleton made out of broken stars, so what do I have to be afraid of? I wonder with unrelenting curiosity; both the grave kind and the effervescent kind, at all the flavors of potential skulduggery that lie ahead.*

The next morning, I found this line from Neal's *Collected Letters*, excerpted from a missive to Allen Ginsberg postmarked March 15, 1949, and forwarded it to Henry Hyatt: "I'm a southpaw…"

The Johnsons at Naropa

In 1974, Allen Ginsberg was called back to Colorado after Neal's death to co-found the Naropa Institute with "fast-talking woman" Anne Waldman, a fellow disciple of the "crazy wisdom" of Chögyam Trungpa Rinpoche. Various Beat greats have consistently passed through Denver and Boulder over the years, many as guest lecturers at the Jack Kerouac School of Disembodied Poetics at Naropa. Said Kerouac School graduate Ashley Waterman, "The amount of writers I have interacted with over the last two years is part of what makes the program memorable. It is a supportive culture that thrives on the visiting faculty and students during the Summer Writing Program, as well as the core faculty throughout the year."

A collection of essays by the late William S. Burroughs, *The Adding Machine*, was largely assembled from audio transcripts of lectures Burroughs gave while teaching there. This book includes tutelary ruminations drawn from his personal history as a writer and lifelong informed contrarian. Burroughs recounts his childhood fascination with reformed criminal Jack Black's bygone classic *You Can't Win*. According to Black's horse's mouth account of the American underworld in the late nineteenth and early twentieth centuries, most hobos and drifters lived by an ethical code every bit as scrupulous, or more so, as the one kept to by law-abiding folk. This was the code of the "Johnson Family," presided over by Salt Chunk Mary, mother of all good bums and thieves. Another notable character in Black's book, "the Sanctimonious Kid," introduces him to life on the grift and mentors him as he gets accustomed to this code, centrally based on minding one's own

The Mile-High Legacy of Kerouac, Cassady & Ginsberg

Naropa University, Arapahoe Campus. *Courtesy of Naropa University.*

Ginsberg, Norman Mailer, Anne Waldman, William Burroughs and Gregory Corso in Boulder. *Photo by Bataan Go Faigao. Courtesy of Wendy Woo.*

business. His reuse, years later, of some of these names and most of *You Can't Win*'s concepts throughout his own books, including the notion of scruples among the dishonored, makes it perhaps the most formative book of his life.

A similar code (MOB, short for "mind your own business") governed the interactions of the Beats' inner circle; for years, Columbia student Lucien Carr's name was omitted from Beat histories due to his wishes, which is admittedly a rare exception, but it speaks to the inherent loyalty of the group. In *The Adding Machine*, Burroughs also shared his viewpoint on politics, drug use, sex, Scientology and other topics from his mental junk shop; he talks about his friends, including inventor of the "Dream Machine" and the cut-up method, Brion Gysin, as well as Beat paragon Jack Kerouac.

Waterman continued:

> *I feel that the Beats are part of my writing lineage. As an undergraduate studying English literature, I was introduced to the work of Allen Ginsberg and Anne Waldman…I found out about Naropa* [and] *wanted to be involved in the temporary autonomous zone that Allen and Anne created. I first saw Anne perform at the St. Mark's Poetry Project in 2012. This experience helped me decide to attend. Her energy and writing is a driving force—there is much one learns from reading and hearing her words. After graduating from the*

Anne Waldman's class. *Courtesy of Naropa University.*

The Mile-High Legacy of Kerouac, Cassady & Ginsberg

Jack Kerouac School, I was Anne's assistant for SWP. Her work continues to influence my work as well as the way I teach creative writing.

Several members of the Beat Generation and its encompassing tradition of cultural nonconformity taught and continue to teach at this fine institution, including, until their deaths, both Burroughses, Corso, Anselm Hollo and Rikki DuCornet, along with modern exemplars of aesthetic experimentation, including post–magical realist Rikki Ducornet and Sonic Youth main man Thurston Moore. Anne Waldman continues to direct the Kerouac School.

Beats at Naropa, an anthology edited by Waldman and Laura Wright (Coffee House Press, 2009), was assembled from Naropa University's audio archives and includes selections from lectures by "Beat" writers like William S. Burroughs, Allen Ginsberg and Gregory Corso; representatives of the Black Mountain School like Charles Olson; and unclassifiable Beat allies like Ed Sanders, Anne Waldman, W.S. Merwin and many others, all of whom served as instructors and advisors at Boulder's Naropa University. One aspect of Naropa's curriculum is the implied necessity of balancing the creative and spiritual disciplines. Perhaps most amusing in this connection are the snippets of lighthearted debate between Burroughs and Naropa's founder, Chögyam Trungpa Rinpoche, over whether astral travel (which Burroughs saw as "fun") should be prohibited from Buddhist practice as a "distraction that may not be shared with others."

Both of my parents were known in the small press scene of the 1970s as the owners of Red Earth Press, publishers of an anthology called *Southwest*. They reportedly hosted Allen Ginsberg overnight at their home once following a reading at a college where one (or both) was a professor at the time. I wasn't sure about the specifics, but one of my friends from the spoken word scene (pen name "Billy Possibility") attended the Naropa summer session in 1994 or '95, and I tagged along with him to a Ginsberg lecture one day to see if that connection would do me any good. After listening to his lecture on the poetry of William Blake as a form of heavenly prophecy, I walked up and faced Allen over a long white table. "You stayed with my parents once," I told him (no finesse).

Ginsberg looked up, bald, bespectacled, big ears. "I may have. I really can't say." It was really him. I told Allen Ginsberg my parents' names—Karl and Jane Kopp—but he didn't remember. "I'm in a hurry, need to rush."

"Okay, well, nice to meet you. Thanks for the lecture. I love William Blake."

Corso and Ginsberg at Naropa.
Photo by Bataan Go Faigao. Courtesy of Wendy Woo.

At the time, it felt right, to have been brushed off by Ginsberg. Made me feel like a rebel. I wanted to be a punk poet anyway, not a neo-Beat. I was nineteen years old, on the hunt for wild sensations.

I met Gregory Corso there, too, later the very same day. I remember he screeched, "Ah, Mr. Alaaaarmclock!" in greeting after I was introduced. I liked that. He was always one of my favorites, a New York jail kid who was a devotee of Percy Bysshe Shelley, with a flair for adding comedy to poetry and humanizing verse. Corso remains my favorite voice among the Beat poets for his skillful reintegration of humor to a form grown staid and mirthless by the time of his arrival. His poem "Marriage" mulls the doubtful prospect of wedded life in a fanciful, image-packed style, and his "Bomb" is nothing less than a liberation of the human spirit from nuclear fear.

Since Corso's death by prostate cancer in 2001, his selected letters have been published as *An Accidental Autobiography*. Where Fante bedded down in the security of a paying job that deadened his output as a novelist, Corso literally lived a vagabond's existence, often spending years at a time in Europe, never holding down a paying job and rarely staying under one roof for a noteworthy stretch. The perfect crime as an accomplished victory. Consisting mostly of letters from the period between 1956 and 1961, when the Beats were burning most brightly due to the smash hits of *On the Road* and *Howl*, this collection is a treasure of literary and personal soul history. From a letter to Allen Ginsberg, October 1, 1958:

> *You nor Jack nor* [Gary] *Snyder can't deny that the three of you are bred with* LOGIC, *and logic is a Western invention; the Orientals are bereft of logic. Didn't you ever consider that you with your logic are incapable of comprehending the illogical? Buddhism is alien to your way of thinking. And you are alien to it. You* THINK. *Meditation is the absence of thinking. But when a Zen meditates, he meditates to* THINK, *and he succeeds, he thinks "imagines" Nirvana. You, jack, Gary can never "imagine" Nirvana no matter how long you lotus because you erroneously eliminate thought from your meditation; a blank mind is a blank mind. And besides you angels are too New York and life and worry or no, and drinkers, eaters, livers, girl man mad, to ever see Nirvana.*

Corso frequently lectured at Naropa. Well-loved Denver musical artist Wendy Woo is the daughter of Bataan Go Faigao and Jane Faigao, original founding faculty at Naropa, in tai chi and traditional arts studies. Corso is referenced in Ms. Woo's moving tribute to her late father, "One Way

The Denver Beat Scene

Corso by Ginsberg. Donated to Bataan Go Faigao. *Courtesy of Wendy Woo.*

Ticket": "Summer nights on the back porch/Gregory teaching us kids to play poker/Poetry and parties through the night/...I'm just a beatnik's kid, I still turned out all right."

There seems to be some kind of disconnect between the poetry scenes in Denver and Boulder. It's hard to classify, and I'm not sure I understand it. Maybe it has something to do with the relative size of the two cities and the effect on the local mindset. That's only a guess. The Boulder poets never liked the slam scene. I've breached the gap only a few times so far. I had a friend who studied at the Kerouac School in the mid-'90s, and she invited Peter Orlovsky to feature at one of the readings I hosted at a coffeehouse.

The Mile-High Legacy of Kerouac, Cassady & Ginsberg

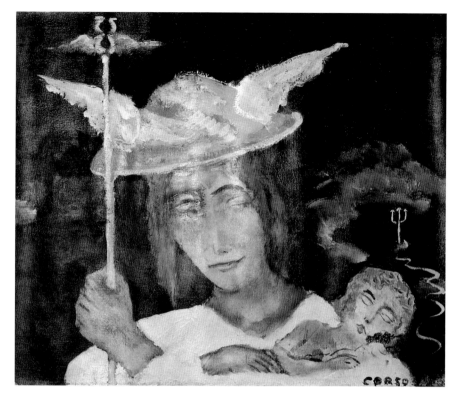

Hermes Taking Infant Dionysius from Sea, G. Corso, 1992. *Courtesy of Wendy Woo.*

Before the show started, I heard Peter telling this girl in a booming, big hoarse voice, "You're not thinking…FAR AHEAD! You're thinking from your EYE to the HOLE IN YOUR ARM!" He told her she should move to Boulder.

"There's a junk scene in Boulder," the girl quavered. I was watching him very closely. I kept waiting for the golden left hook. He had this aggravated, red stress spot in the middle of his forehead from his Third Eye trying to come out all his life. His pants were hiked up ridiculously, way too high up, almost to the top of his great, round belly. He wore yellow paisley braces and a fat tie. He moved around the crowded in these slow, ungainly bounces. His head was shaved so he looked like W.C. Fields or Aleister Crowley in the last days. He kept going up to people and introducing himself—"Peter Orlovsky!"—and leaning over tables, sticking his hand out to be wagged.

There was a long, disconnected preamble delivered very passionately in a hoarse voice, arm waving onstage, linking the Mafia, Hitler, cocaine addiction, the Civil War and Newt Gingrich in an incomprehensible tirade

of self-betrayal (for which nobody there loved him except me). I thought it was brave. He told us about the evils of cocaine addiction and a story of how Hitler used to shoot up cocaine and then line up women on the floor and shit on their breasts and heart and make them lick his asshole—"And THAT'S why a POWER-HUNGRY PERSON…should NEVER be allowed…to SHOOT COCAINE!"

When I told him my name was Henry Alarmclock, he grinned and said, "Really?" I kept waiting for the golden left hook, but it was all one big golden left hook, and there was nothing to wait for. Watching footage of Orlovsky berating Gregory Corso for smoking cigarettes and not being a vegetarian (rather than mythologize the Beats) at a panel they both took part in during the tribute to Jack Kerouac on April 5, 1973, I was reminded of the poet's lovable irascibility.

Sam Kashner was the very first student at Naropa when the Beat Generation was in its twilight years, as related in his memoir, *When I Was Cool*. Some members, like Ginsberg and Burroughs, had achieved international fame, while others, like Corso, had not and were coming to the realization that they might never receive the recognition they desired. In his new role as student, secretary and de facto psychiatrist, Kashner was caught in the crossfire of old arguments, finding himself in hot tubs with Ginsberg and on field trips to the marijuana ranch then cultivated by Burroughs and his failing son, Billy, somewhere off campus.

Three friends from the Denver hip scene invited me on a road trip to meet Burroughs in Lawrence, Kansas, shortly before his death in 1997. They were successful in attaining a momentary encounter. "The night before," said one, "I broke off this piece of rotted sideboard from the motel room wall and started hobbling around the room pretending to be an old man with a cane. I was trying to channel Burroughs, and it worked!" The same friend said he saw Burroughs move from one end of the house to the door with alarming speed through the picture window as the three of them entered his yard the next morning—"It was almost inhuman how fast he moved, insect-like."

On this occasion, William S. Burroughs told my friends, "Things come in streaks. When you're winning, double up. When you're losing, fold. Walk away." This Jack Blackish concept for gamblers with life can be seen in *The Adding Machine* and elsewhere in Burroughs's writings and was probably one of many stock phrases Bill used to abbreviate unwanted visits like theirs (the last two words—"Walk away"—being the whole of his point). Any lack of hospitality to unexpected visitors in no way undermines my opinion of William S. Burroughs as one of the most astute observers of American

culture I have encountered, and *The Adding Machine* is one of the greatest books on that troublesome subject I've read, one unlikely to have emerged from a more traditionally styled institution of learning.

Naropa began as an institute modeled on ancient Buddhist learning centers in India and was described by Waldman and poet and onetime faculty member Andrew Schelling as "part monastery, part college, part convention hall or alchemist's lab." According to former Naropa student Steve Silberman, Instructor Ginsberg once lamented, "Argh, you're all amateurs in a professional universe!" upon learning that most of his students had failed to register for meditation instruction, while handing out "Celestial Homework" in his Literary History of the Beats class. Says Challis,

> *The Jack Kerouac School of Disembodied Poetics is the logical extension of what Ginsberg has been achieving in that area which Americans called "poetics"—a sort of hinterland to the actual process of writing the stuff—ever since the publication of* Howl. *Ginsberg's own Buddhism (as well as that of other poets closely associated...like Ginsberg's roommate of a quarter century, Peter Orlovsky, and his co-director...Anne Waldman),*

Thurston Moore at Naropa University. *Courtesy of Naropa University.*

which he has practiced since the fifties, finally led him to seek out Trungpa, a younger man, to be his guru...As Ed Sanders said, if they're not writing Ph.Ds about the Disembodied School yet, they soon will be.

Since Allen's death in 1997, the Kerouac School has been piloted by the discerning eye of self-proclaimed "Outrider" Anne Waldman. From its website: "The Jack Kerouac School cultivates contemplative and experimental approaches to writing. Our esteemed faculty teach literary arts in innovative ways that foster both rigor and creative expansion." Guided tours are available at all three Naropa University campuses. The first campus is located at 2130 Arapahoe Road in Boulder. When you're there, don't forget to check the Allen Ginsberg Library, inaugurated in August 1993 and embossed with a plaque quoting English poet William Blake:

He who holds to himself a joy
Doth the winged life destroy
But he who kisses the joy as it flies
Lives in eternity's sunrise.

NEAL CASSADY:
THE DENVER YEARS

Local director Heather Dalton's *Neal Cassady: The Denver Years* had its first screening on June 26, 2014, at the Sie Film Center across Colfax from its namesake's alma mater, East High School. For the past ten years, Dalton has been interviewing Neal's relatives and intimates—from his son John Allen Cassady to old friends like David Amram to his widow and amanuensis, the recently passed Carolyn Cassady—to effect the most comprehensive tribute possible. She is a regular participant in the annual tradition of Neal Cassady Birthday Bashes at Marilyn Megenity's Mercury Café each February 8.

Some efforts in the continuing effort to translate things Beat to the movies are more to my taste than others. Since the turn of the century, there have been two filmic attempts to canonize Beat catalyst Neal Cassady—Noah Buschel's eponymous film and Heather Dalton's *Neal Cassady: The Denver Years*. While Buschel's *Neal Cassady* seems a well-intentioned effort at sympathy with the contradictory aspects of Neal's history and personality, highlighting his mythical search for his father, a Larimer Street wino, Dalton's film is the first and only one to commemorate Neal's roots. "I made this film for Neal and for Denver," said Dalton, "It seems our own literary history had been overlooked for quite some time, but it feels that now people are seeking it out and I am honored to be a part of that growing tribe."

Your reporter first became aware of Heather Dalton in the 1990s as a vocalist and guitar player in a succession of Denver punk bands,

The Denver Beat Scene

This page and opposite: Art from *Neal Cassady: The Denver Years*. Courtesy of Daniel Crosier and Karl Christian Krumpholz.

including Star Hustler and the Pin-Downs, meanwhile maintaining and incrementally improving her impressive self-made status as faithful, productive employee of Denver public television station Channel 12, beginning as an intern and going on to host local rock video show *Teletunes* until it was taken off the air sometime in the '90s. She currently hosts a show on public access cable network CPT12 called *Sounds on 29th*, hosting a selection of musical artists local and otherwise. Dalton also cohosts another program on the same network, a talk show called *Late Night Denver*.

The Mile-High Legacy of Kerouac, Cassady & Ginsberg

The screening opened with a preshow reception in the lobby with complimentary drinks and food. Elbow to elbow with other ticket holders in the buffet-bar area, your reporter was reminded of the line in Gregory Corso's poem "Marriage" about the grubby, bearded handful of his friends at a wedding, "just waiting to get at the drinks and the food." Co-producer

The Denver Beat Scene

Daniel Crosier, whose art is featured in the film, presented me with a few complimentary prints of wood carvings he'd done of Neal's face and introduced the film's other artist, Karl Christian Krumpholz—author of the comic tribute to Colfax Avenue, *30 Miles of Crazy*—with whom I exchanged business cards. The screening sold out close to show time, and several people were turned away. Even Bob Hyatt had to play the "son of Neal" card to get tickets for himself, Vera and Henry. Neal's children with Carolyn, all of whom appear in the film, were in England finalizing the details of her estate or they would have attended.

Dalton has said that she felt driven to make a film about Neal's thus far barely considered days in Denver, much as Neal himself might have felt driven to do or be one thing or another throughout his life, as an artist of self-correction. She drafted a heartfelt letter to the Cassady estate, well aware that other people had approached Carolyn with similar projects previously and had been served cease-and-desist letters. "I outlined specifically what Neal's legacy meant to me and the city of Denver, and she agreed to meet with me to consider the project. After a period of, shall we say 'courting' her, she agreed to allow me to proceed. What happened after that had a lasting impact on my life. A very close friendship evolved, and my respect of her, which was already deep and profound, became even more intense. She was one of the most incredible women I have ever been blessed to know, and I learned so much from her well beyond the scope of this documentary."

No one expected such an overwhelming reception, least of all its directors and producers, including Heather Dalton and Colorado Public Television Channel 12. The theater was packed; myself and my lady friend found seats in the very front, and I dutifully kept my neck at a ninety-degree angle straight up and ahead throughout the excellent, edifying feature, the first film to commemorate Neal's days in Denver before adding his spark to the powder keg of the world at large. A ten-year labor of love on the part of the director and all the producers, including Joshua Hassel, this film is full of heart. Its debut screening was a personal landmark for lots of great people in all kinds of ways, and I was glad to join that experience, speaking briefly before the screening by way of promoting my limo tour job and soliciting inside connections for the *Beat Guide*. Hassel spoke with your reporter briefly about the roundabout course taken by himself and Ms. Dalton in first contacting Carolyn, involving travel back and forth to her home in England and a blithe contrariness on her part ultimately giving way to the generous sharing of opinions and memories at the heart of *Neal Cassady: The Denver Years*.

"At one point, she didn't even want to talk about the Beat stuff at all," confided Hassel. "She just wanted to talk about herself."

"I'm sure she has a lot of stories."

I was pleased to learn that her *Love, Always*, which I'd assumed was a collection of letters to Cassady, was, in fact, a 2011 English-language Swedish documentary film written and directed by Malin Korkeasalo and Maria Ramström that centered on Carolyn's life as Neal's amanuensis and the executrix of his estate and legacy, in particular her concerns that Jack and Neal's true nature was in danger of being subsumed by their sensational reputations in popular culture that failed to take account of each man's inherent goodness. Carolyn Cassady's personal history as the child of landed gentry who, following her husband's example, became a devout follower of "sleeping prophet" Edgar Cayce as an adult—she remained a devoted student of the Cayce philosophy until her own death in September 2013—is rich in lively individuality. After contacting the Cassady estate for image use permissions, I received an invitation to a memorial for Carolyn Cassady to be held on September 20 on the West Coast on the one-year anniversary of her passing. Financial conditions being insolvent—that limo job having morphed into a supper club job still in development (stay tuned!)—I had to decline. Denver Beat historian Mark Bliesener was present and, along with Al Hinkle, George Nelson, John Gorley and San Francisco Beat Museum owner Jerry Cimino, was asked by the Cassady family to speak at the memorial. He provides the following report:

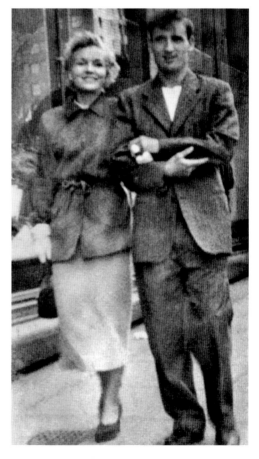

Neal and Carolyn's wedding day. *Courtesy of the Cassady estate.*

> The Cassady Clan both immediate and extended, gathered at the Café Stritch in San Jose, Ca. to celebrate and remember Carolyn's talent, beauty, wit, wisdom and lust for life and truth. All three of Carolyn and Neal's children Cathy, Jami and John Allen, were in attendance as well as their three grandchildren and several great-grandchildren. The walls of the popular downtown San Jose jazz club were covered with photos, paintings, costume design sketches, letters and other memorabilia illustrating the depth of Carolyn's many talents. Tables were set with bouquets of lavender and her favorite yellow roses. Small American and British flags were also displayed throughout, recognizing Carolyn's dual residency. I spoke about Carolyn as Mother—to her family, the Beats, and those of us fortunate enough to enter her sphere. In a time when women were culturally confined to the kitchen and bedroom, she demanded more. Yet Carolyn did embrace the "traditional" role of Mother, and in that capacity, expected and encouraged greatness from all she interacted with—a big job—and one she accomplished with grace, energy and discipline. She provided a sense of home and security to all, sometimes against incredible odds. In the process, Carolyn Cassady became one of the most important and influential women of her generation. Prankster George Walker, who was "on the bus" with Neal Cassady and also in attendance at Carolyn's memorial, summed up this impact best, saying, "The Cassadys were the first family of the American counterculture."

"I started off on a magnificent journey to tell the story of Neal Cassady and his time here in Denver," Heather Dalton began her post on the Denver Years Facebook page upon that film's completion, continuing:

> My path was not a direct one nor was it ever certain. There were moments that illuminated my steps and at other times, self-doubt would slow me down. The outpouring of love and support has been the driving force behind this project and I am thankful every day that I have been able to take this ride, and what a wild ride it has been! Along the way I have been blessed to meet fellow passengers and some the most amazing people that have changed my life profoundly and have become a part of my fabric. This past year marked the passing of Carolyn Cassady, a woman I can honestly say was my hero and my friend. I deeply regret that the film was not completed before Carolyn died. She was a constant champion and supporter and in tribute, I dedicate this film to her.

The Beat Generation remains among the more powerful literary and cultural influences I've encountered. I have attempted to provide here an account of the movement's effect on American literature and culture

complete, with a guide to landmarks of its passage through Denver, Boulder and other parts of Colorado. The movement's effect is subjective. Where one aspiring writer might have earnest hopes of emulating Kerouac's perceived "total honesty," misguided sorts might see Neal Cassady's burning spirit, as

Poster for *Neal Cassady: The Denver Years*. Courtesy of Heather Dalton.

portrayed by Kerouac, as a cue to live fast and die young, blithely ignoring the upward-straining aspiration to perfection that seemed to drive that modern Prometheus; by the same token, Allen Ginsberg's overt homosexuality or his devout Buddhism might turn some readers off, and feminists might well prefer to ignore the whole business after learning of Neal's womanizing and the lack of popular female or non-white Beats or fail to be captivated by these examples upon discovering them. It's all about angles, as Challis noted in *Searching for Kerouac*:

> For all their bilingual understanding of Celine, Proust, Shelley, Blake, Nietzsche, Dostoevsky, the Beats were Americans. Posterity and hindsight will see to it. My Beat Generation might not exist for another living soul, but the Beat Generation was not a chorus of fags, a Roman Catholic group, or an East Coast, Californian or Internationalist movement. And anyone who wishes it to be any of these may, and will, see it as such….Nothing important ever dies and what they were about is continually discovered by succeeding generations. Neal Cassady is alive and well in a tortoise egg.

And in the lives of his inheritors, genetic and otherwise, in Denver and everywhere else, as I've shown here, if only in part.

The Beats continue to be a strong source of inspiration for writers, artists and musicians inclined to make a dent in the world for better or worse. I remember I felt like I was betraying Kerouac's model in calling myself "Henry Alarmclock." But even Jack used fake names for the people in his life who made it into his books, and the phrase "Beat Generation"—whoever said it first—was designed to make those writers stand out from the norm. It could be that Jack Kerouac started a trend in American popular culture that has developed to the point that fabrication has to be complete to enchant anymore. Where spokespersons for anything truly contrary to the norm have to come off as caricatures to get through.

Denver creative life has seen a lot of self-made superheroes come and go over its decades as the Beat Nerve Center—Henry Alarmclock, the Great Grapefruit, Billy and Benjy Possibility, Peter Yumi, Wang Zen, "88," Sara Century, ChriShop, the Hunger Artist—and many others. Whenever one of these people shows up in my immediate radius, I feel a sort of caretaker's instinct. Asked one recently, after hearing me nutshell the Beat Generation nutshelled by me as having inspired the '60s, "I'd like to start a counterculture. How do you do it?"

"Hmm, I don't know. Try Facebook?"

The Mile-High Legacy of Kerouac, Cassady & Ginsberg

Starting in the late '90s and lasting until New Year's Eve 2001, my alter-ego, Henry Alarmclock, was part of an artists' collective in Denver called Bleeding TVs of the Angels. We staged potlucks at the Mercury Café and other locations, with black lights and glow sticks—no slated performers, but instruments, art supplies piled on the stage and signs everywhere: "You Are the Show." These were efforts to subvert the audience/performer dichotomy in emulation of Guy Debord's Society of the Spectacle. Guests would arrive, mill around, looking at all the stuff and the signs for a while before getting the hint, at which point, inevitably, wild, spontaneous, creative jams would ensue. Some of the most far-out artistic weirdness in which Henry Alarmclock ever took part. Few people remember it now—even something that strange. Despite its conceptual leanings, I can see now that the Bleeding TV events descended lineally from the "Human Be-In" hosted by Allen Ginsberg, Gary Snyder, Timothy Leary and other countercultural luminaries in San Francisco's Golden Gate Park in 1967. According to poet and Fug Ed Sanders, this was the point at which people stopped calling themselves "beatniks" and started to call themselves "hippies."

Things have changed. Most people have a social media presence on one or more networks these days, simultaneously making us all more accessible and meeting strangers less impressive. It's like being all places at once, catching glimpse after glimpse of others' passions and commitments, scrolling down the newsfeed, where completely contradictory notions coexist. It's a river we flow down, directing our course with what we "like" and what we "hide" as we design our energy. More and more events arise in the national media that are more and more polarizing: black against white, men against women, straight against gay. Supermarkets are amazing to me. That we live together in cities. So much duality is manifesting so overtly lately that some metaphysicians believe this is the passing of that age manifesting as a healing crisis. A choice is being made, and maybe it starts with our newsfeeds. The Beat Generation helped start the trend of creative rebellion in popular culture post–World War II, and Denver, Colorado, has hosted its efforts since before that movement had a name up to the present day, as Nerve Center for its principals and their admirers and successors, myself included. Popular culture has changed inestimably since Denver's Beat heyday. You can't judge a book by its cover today, even if you read between the lines.

Just like Neal Cassady getting pulled over after tootling the masses from the Merry Pranksters' Magic Bus, everyone still has to fight for creative control of the movies they're living. Neal couldn't have predicted the effect he'd have on Jack, and Jack couldn't have predicted the effect his words

would have on Neal or anybody else. I saw a meme on social media the other day of live greens spilling from a crack between concrete plates of sidewalk, irrepressible, natural, growing green life. Below it somebody had stenciled the message "Resistance," with an arrow pointing up at all the reeds and sprouts and flowering leaves of grass shooting out of the hard rock overlay. The laws of nature.

All About Angles

The skin around his left eye swelled up, and poet Henry Alarmclock caught sense of an expanding mosaic of mazelike patterns just beyond the edge of sight on that side. He disguised himself with shades and slunk into the organic market a few blocks away, where he bought two little bottles of lemon oil and a blue glass spray bottle. When he got home, he mixed the oil with water and a dash of dish soap for the perfect homemade spider repellent and then shook it up in the bottle and sprayed it all over his mattress and pillows and the air conditioning vent behind his bed. The website he'd found had also recommended alternating hot and cold compresses to make the swelling go down. Henry wrote a few more lines:

> *Almost ready to unleash myself into this new black night of*
> *springtime coming on Colfax*
> *to feed my stomach some hot seeds of protein*
> *—go find some hot stuff out there for the family of dogs*
> *in my belly, out there in what connects all open doors, the night,*
> *amid streetlamps and oil spills and shuffling zombie punks*
> *who show you the blunt edge of night with their piss-yellow eyes—*
> *the night connects all opened doors, we're all here in America tonight!*

Lamar Cobson was getting married that weekend in Santa Fe, New Mexico, and Henry had purchased Greyhound tickets there and back from Denver online the day before. After the water finished heating, he stuck a

wadded T-shirt in and pressed it to his eye for about five minutes, donned his shades and caught the bus through crowded hot streets to the station downtown to pick up the tickets. The girl behind the desk told him that the route hadn't gone out the last few days due to effects of the Arizona wildfire at the stop in Raton, and he'd have to call back early the morning of departure to see if it was leaving. Lamar and Henry met on Power Mountain in Vermont. Several people had been standing around the picnic table outside Greystoke dorms at one of the grad school residencies one afternoon a few years ago when a cloud of curious bees bumbled in to smell all the colorful people. The other students ran away clutching their study outlines, screaming and hissing over their shoulders. Henry and Lamar just stood there. "They don't mean any harm," explained Lamar. "They see colors and think it's a flower."

"Right," said Henry. They knew.

After graduating from Power Mountain, Henry had feinted briefly at the notion of being a college teacher before committing fully to a make-or-break attempt at maximization of his own creative output, be it literary, artistic or musical. He had a little savings, a steady gig writing online book reviews that barely paid and was the editor of a webzine that never brought in money, only contacts. His band the Drainpipes had experimented with a few other musicians, both female, but prior commitments to school and work had dissuaded them from continued participation, and the band was on hold since Nelson's skiing accident.

When Henry got back to the pad from the store with his microwave food, he checked the news from Raton, which was all about the health hazards of inhaling particulate matter and soot of unknown composition. Henry decided to get a refund, exchange the tickets and reschedule his trip to Santa Fe. He sort of liked the idea of a post-apocalyptic Greyhound trip through burnt cinder towns, but he didn't want to breathe that toxic smoke. His eye was swollen, and he had a pain in the small of his back from a few months sleeping on an extra-soft mattress he'd found in the alley behind his apartment.

Freelance writing was an uphill climb. You could never tell if the people who hired you would pay. Sometimes they figured publishing your stuff would make you happy, but it didn't pay the rent. Henry was having a dry spell lately. One local company called SeaMonster had purchased some comic book scripts from him several months ago and then switched to distributing MP3s instead and would soon be publishing the short fiction submitted by Henry and others in thirty-two-page "booklets" to be marketed on Amazon. It was a whole new format, liable to derision by the stalwarts upon its debut, especially when you

considered the clownishly undisciplined nature of Henry's contributions to SeaMonster so far. But the time felt ripe for this kind of grass-roots action, what with the recession having made everything seem equally likely to sink or swim. Henry sure had wanted to make Lamar and Cordelia's special occasion. But his not going means the Drainpipes can practice again sooner, he reminded himself, and once they have recordings, SeaMonster can market those too. Yeah.

His friend Nelson's wife and three kids went to a swap meet, and the Drainpipes had their first practice session in a few weeks. Nelson met him at the door on crutches, and Henry was especially conscious of his own eyelid drooping comically while debuting his latest song, about cellular memory coming unblocked, which was supposedly one of the effects of the three eclipses that month. Nelson seemed abstracted, showed him the before and after X-rays of his shattered heels, the first featuring floating smashed chunks of bone, the second starring the same shattered chunks held together with screws and bolts. "I've never really thought about the inside of my foot before," said Nelson, "but knowing all that metal's in there now feels so unreal."

"Our emotional bodies and our bodies," commented Henry.

More online investigation led him to another site with identical pictures of eyelid wounds suggesting that his affliction was probably something called a "sty," or clogged eyelid gland, often mistaken for a spider bite. The idea of tiny unnoticed glands all over the human body that can become clogged and swell if obstructed made Henry think about Nelson's X-rays. How barely we know ourselves. He'd been applying skin lotion to that part of his face for the last few months, which he hadn't used to. Maybe that was it. He had some rubbing alcohol and Q-tips inside his medicine cabinet and decided to swab the area a few times daily, which stung him a little. Just something he had to go through.

At the reading that night, an old man with a smiling pink face and a wisp of white hair was the host. The sign-up sheet lay on the glass case beside him. He handed Henry a red pen but wouldn't let him use it right away. "First of all, let me ask you, would you consider purchasing my new chapbook, *Event Horizon*...for five dollars? How about *A Perfect Loaf* for *four* dollars? That's my *other* chapbook!" His cheeks shone, and the foolish smile widened. "Or how about *Visions of the Unicorn*? That has a few of mine. It's only three." Henry shook his head. He signed up fifth and then took a seat near the stage.

First up was an old guy who told them he lived in the woods and then read a long poem about it: "all the underbrush tossing and turning in the wild humid wind"—on and on in that vein. Then a mousy, gray-haired woman read a few haikus on butterflies and snails. One more person read, a skinny

The Denver Beat Scene

guy in a buckskin jumpsuit who called himself "Johnny Q. Kerouac" and then called for a ten-minute break. Henry asked the guy in the fringed buckskin suit who'd announced the break, "Can I take a look at that list?" and J.Q. Kerouac produced a wholly different list—in pencil—with no Henry on it.

"No, it was a list in pen." Henry looked around the room. There were people everywhere, but the man who'd signed him up was gone. He told Johnny Q. the story of what had happened, which caused him to paw through his satchel of papers, extracting another list—"Was it *this* one?" His hands were twitching.

"No, it was all in red ink," said Henry. "Listen, is that old man crazy? He tried to sell me all these books before he'd let me sign up."

Johnny Q. bristled noticeably and shook his head. "*I'm* the only host tonight, and there *might* be room for you. *Maybe*. I really can't say."

When Henry Alarmclock took the stage, he decided to read the one about the tree root Tarzan had given him at the Classroom coffeehouse, spray-painted red, with a padlock hanging from one of its branchlike red veins. "My wife's been sellin' these at the reservation for twenty bucks," he had explained. Henry had taken the thing home and hung it from a hook in the ceiling right over his mattress.

The audience looked at him. "The heart of Denver hangs over my bed on a leather thong," he shouted at them, "red and brown and bursting with ventricles, stretching its long slick legs out in all directions like kudzu, like Grandfather Yog-Sothoth, The Thing that Should Not Be—the heart of Denver is an Octopus!" Henry read through the whole thing and then walked off the stage and right out the coffeehouse door and all the way back to his pad off Colfax Avenue.

His droopy lid was barely noticeable by the time of his old friend Josh Lawlor's wedding in an Anglican church in Westminster. He got a ride there from the sleek, attractive Darla Prescott, an old friend recently resurfaced on social media, perhaps his strongest early model of female beauty. Henry sat next to her wearing his new string tie through the service and subsequent reception at the Knights of Columbus Hall on Grant, stepping outside of that long room at one point with Penny Shattucker, an acquaintance from the spoken word scene.

"I've always liked your writing," said Penny, her red eyebrows flashing. "So it makes sense you're a writer now." She knew about the webzine he'd been editing.

"Thanks, Penny." Henry didn't mention the Drainpipes, who hadn't done anything for a couple of months. It was true he was a writer of some kind.

Darla Prescott gave him a ride home through the hot afternoon. "June's the wedding month," she told him on the way.

"Oh yeah, is that the tradition?"

He got an e-mail that night from Steve, the CEO of SeaMonster, the comic book publisher turned MP3 distributor slash publisher of booklets. Steve told Henry that he had a scanner in storage he'd like to give him. "I thought you might be able to put it to a better use." No signs of trouble yet, but Henry was given to imagining all manner of intrepid plots against him. Who was this "Steve" character?

He came over the next afternoon, slight, twentyish, wearing all black. The skin of his forehead and around his eyes was bright red except for a pale patch in the shape of his sunglasses. He dropped off the scanner and showed Henry how to use it. There was a lull in the small talk at one point, and Henry said, "Yeah, I got bit by a spider last week, right on my eyelid. Or it could be a sty. That's what's on my mind."

Steve made a face of polite disgust. "I got bit by a bedbug last week. You ever seen one of those? They look like little roaches."

"Ugh, don't even bring that thought in here. Those are epidemic lately in Denver, you know. Last week, you say?"

"Well, it wasn't my place. It was just a place I was staying."

Henry thanked Steve for the scanner and gave him some lotion for his burnt face before he rode away on his bike, telling him that once the Drainpipes had recordings, he'd send those along, too. He reminded himself not to look a gift horse in the mouth. Something very much like this had happened to Bukowski—John Martin had appeared from nowhere and promised him $100 a month for life in exchange for first publishing rights. That evening, Henry posted a blurb promoting SeaMonster on social media and sent Steve an e-mail asking if he'd be interested in publishing longer works: "I just finished a novel, 259 pp., and have several target areas of interest in mind." Steve wrote back and said he was very interested, so Henry e-mailed him the latest PDF and a synopsis.

On social media that evening, he saw some pics of a towering red sky and smoke behind ridges of trees looming over that lab in Los Alamos, which terrified him in a cinematic way. When that tsunami knocked the plant offline in Japan, he'd briefly seen it as the beginning of a chain of short circuits, every concentration of misguided energy about to backfire. Which hadn't ended up happening. Or was it happening now? Before the southwestern wildfires, there'd been a panic on in the media about a flooded nuclear plant near Omaha and another upriver from it.

Lamar sent him an e-mail after returning from his honeymoon in Belize. "Los Alamos is out of danger now. The fires still look pretty bad, but our monsoons have started, so your wish of rain is already coming through. Keep wishing as we need a lot more." It rained very hard the next day in Denver, a real explosive outburst, flooding parts of downtown like a fire hose had been turned on. Climate change. Henry hadn't heard anything about those flooded plants in Nebraska for a few weeks. The next time he went to the grocery store, he ran into his friend Miranda. Besides being an artist and freelance yoga instructor, Miranda worked nights tending bar at one of the Broadway dives, Killer's Korner. Henry thought she was beautiful and they were good at talking to each other, but she seemed to have a few boyfriends already and their relationship was platonic. "So how are you?"

"Oh, not so good," she sighed.

"Well, hopefully you don't have to work tonight?"

"Oh, yes," she said, steering her cart out of the path of an oncoming wheelchair piloted by a bird-faced woman. "And it's panties behind the bar night, which I hate."

Henry had seen her use that phrase on social media. "Is that actually the name of the job designation?"

"They make me wear panties behind the bar."

"Well, shit. That's totally lame and sexist and awful. You should—" To Henry's right, an overweight man in a green shirt heaved a sigh as he bent to address the row of cans on a lower shelf. The store was filling up.

"I should get a new job. Right now I'm just accepting all this."

"That's why these things pile up, I think, to make us change."

Henry Alarmclock stopped into Miranda's house for a glass of water on the way back to his apartment. They were sitting in her living room, her on the purplish couch and Henry kneeling on the floor across a glass coffee table from her, when she remarked, "All my friends are getting married lately."

"Me too. I went to a wedding a few days ago. I think a lot of people see getting married as completion in a way. You know? Like they want to put a capstone of completion on their lives...That's so not me."

Henry ordered a new bed from the mattress place. A couple of workmen dropped it off, and he discarded one dead plant from the row on his windowsill and rearranged all his bedroom furniture to suit the new raised pallet. Lying on it in the darkness at the end of the day, seeing or just imagining spider web–shaped energy patterns on his left, Henry was aware of a faint, strange wobble, like he was going somewhere on a spaceship. His back felt a little bit better when he woke up the next morning. He remained conscious of a

slight heaviness in his left eyelid, though any irregularity in size was probably impossible for others to notice by now.

> *Someone is waiting for me on the other side*
> *of a rainy window in the future of raining nights*
> *and long dark quiet highways. All the angels wearing roadside neon signs as*
> *pendants and trinkets and bracelets,*
> *traditional soft cloudy angels of cotton and peaceful*
> *leaning down from the clouds to say hi.*
> *How the air shines around streetlamp bulbs.*
> *How the shuttle bus gives a disgruntled snort*
> *just before its bell rings, and the doors swing shut*
> *just before you get there.*
> *Whose legs are entwined with another's.*
> *Who reaches out to touch the heart of Denver with her leg.*
> *Who am I talking about!*

Henry Alarmclock was walking down the sidewalk one day and ran into some guy testing his remote-controlled drone in front of his house. Maybe this is what it felt like in the old days when they first saw television, he thought. When time gets slippery. "Yeah, it's a drone," said the guy. "They got GPS now." Henry had begun to notice peace signs blooming and spreading in the Denver sidewalks lately. The first one he saw looked man-made, but he found more and more as he walked down the sunny sidewalks from his house to the credit union to cash the latest freelance writing check. All less perfectly stylized than the first, undeniably imperfect and organic and expressive of some impulse on the part of God or nature or geology or something else mysterious and powerful. He couldn't tell now if the first one had been man-made after all or not. There were so many cracks in the sidewalk. Of course, anyone else might have seen pitchforks, or the skeletons of fish. It was all about angles.

Appendix
BEAT TOUR STOPS IN AND AROUND DENVER

CENTRAL DENVER AND CAPITOL HILL

The Colburn Hotel and Charlie Brown's Bar and Grill (980 Grant Street, Denver, 80203): Carolyn Cassady's residence while studying at Denver University in 1946 at the time of her meeting with Neal; where Ginsberg lived briefly, wrote his unpublished "Denver Doldrums"); featuring a bar downstairs that serves food where Cassady, Kerouac and Ginsberg hung out.

9th and Grant: Former site of Allen Ginsberg's apartment in Denver, now the site of a Denver Public Schools administrative building.

Colorado Outward Bound School (945 Pennsylvania Street, Denver, 80203): Neal's connection to Columbia University in New York and its students, including Jack Kerouac and Allen Ginsberg, had connections to this joint.

Tony Scibella's Ogden Books (Colfax and Ogden, closed): Formerly a hotspot of beat literature in Denver. Its proprietor, Tony Scibella, is the author of *The Kid in America* and several other works, all available at www.amazon.com.

Denver Botanic Gardens (1007 York Street, Denver, 80206): Featuring an arboretum designed by lifelong Kerouac friend and correspondent Ed White.

Appendix

Molly Brown House Museum (1340 Pennsylvania Street, Denver, 80203): Former residence of the "Unsinkable" Molly Brown, the *Titanic* disaster survivor.

SiE Film Center (2510 East Colfax Avenue, Denver, 80206): Site of the first screening of Heather Dalton's independently produced feature, *Neal Cassady: The Denver Years*.

East High (1600 City Park Esplanade, Denver, 80206; Colfax and York): Neal Cassady's alma mater. He never finished a class there and was awarded a degree posthumously.

1729 East Colfax, north side of Colfax, just past Williams: Formerly the Oasis, a teen hangout frequented by the young Cassady when a student at East.

Civic Center Park: Bordered by the state capitol, the City and County Building and the Denver Art Museum. A landscape featured in many of Allen Ginsberg's early poems on Denver.

The Denver City and County Building (1437 Bannock Street, Denver, 80202): See above.

Holy Ghost Catholic Church (1900 California Street, Denver, 80202): Neal served as an altar boy at this church for a few years.

Lower Downtown and Five Points

Tarantula Billiard and Bar (1520 Stout Street) in Downtown Denver.

Zanzibar Billiards Bar and Grill (2046 Larimer Street, Denver).

The Mercury Café (2199 California Street, Denver): Marilyn Megenity's Mercury Café is cash only and run by sustainable principles and has a long tradition of hosting spoken word and music.

Ebert Elementary (410 Park Avenue West, 19th/Glenarm): Neal attended.

Appendix

Denver Dry Goods Building (15th and California Streets): Originally built in 1889, the store was expanded in 1898, 1906 and 1924. It was converted to apartments in 1994.

United States Post Office (Byron White United States Courthouse, at 18th and Stout Streets): Neal wrote about it in *The First Third*, in particular the motto carved on the marble bench outside.

The Metropolitan (2100 Delgany Street, Denver): One of many flophouses stayed in by Neal Cassady Sr. and his son in the 1930s. No longer stands.

The Snowden (22nd and Stout): No longer stands.

Za Za's Barber Shop (lower side of Larimer between 17th and 18th): Where Neal Cassady Sr. worked. No longer stands.

Sonny Lawson Park (2301 Welton Street, Denver, 80205): Named in honor of the Denver black entrepreneur and Radio Pharmacy founder Sonny Lawson. Mentioned in at least two of Kerouac's works. "Down in Denver, down in Denver, all I did was die."

The Radio Pharmacy (corner of 26th and Welton Streets, Five Points neighborhood): No longer stands.

St. Elmo Hotel (1433 17th Street, Denver): Formerly a rooming house, one of the places where Neal Cassady Sr. stayed.

Pride of the Rockies Flour Mill (20th Street, near the ballpark): Where Neal had his first transcendental experience. No longer stands.

Northwest Denver

Elitch Gardens Theme Park (2000 Elitch Circle, Denver, 80204): Where Jack, Neal, Ed White and others went to smoke marijuana while in Denver.

The University of Denver (2199 South University Boulevard): Where Carolyn Robinson (later Cassady) was a student.

Appendix

Denver Art Museum (100 West 14th Avenue Parkway, Denver, 80204): Allen Ginsberg was a fan.

Downtown Denver YMCA (25 East 16th Avenue, Denver, 80202): Where Neal Cassady first met Al Hinkle; where his "illegitimate" eldest son, Bob Hyatt, learned to swim before he had any awareness of the connection. Both also went to the 20th Street Gymnasium at 1011 20th Street, Denver, 80202.

The Yards at Denargo Market (Brighton Boulevard and 29th Street, in Denver's RiNo district, 80216): Former site of a wholesale fruit market where Jack Kerouac worked briefly. Now an apartment complex.

Jack Kerouac's former residence (Lakewood, Colorado, 80226): Bought in 1949 with the proceeds from his first novel, *The Town and the City*.

Colorado Convention Center (700 14th Street, Denver, 80202): East side at ground level, collage with faces of Neal, Jack, Allen and others considered to be notable in Colorado's history.

15th and California, northwest corner: Plaques in sidewalk honoring Cassady, Kerouac and Ginsberg—ironically, the same spot where a local poet was struck by the light rail years ago. This was the first death by light rail in Denver.

My Brother's Bar/formerly Paul's Place (15th and Platte): Former hangout of Neal's, with framed letter by Cassady in reform school sent to Justin W. Brierly, his eventual connection to Columbia University.

The Roxy (2549 Welton Street, Denver, 80205): A jazz club they dug.

The Casino Cabaret (2637 Welton): Now Cervantes' Masterpiece Ballroom. More cool jazz.

El Chapultepec (1962 Market Street, Denver, 80202): The best jazz.

Neal Sr.'s former barbershop (26th and Champa): Small brick building sometimes used by neighbors as a billboard.

The Rossonian (2642 Welton Street): More jazz!

Appendix

William S. Burroughs Jr.'s apartment (Colorado Boulevard): Billy lived on the east side of Colorado Boulevard in the Oxford Arms—two sixteen-unit apartment buildings—that were just south of the former corner retail stores at 8th and Colorado Boulevard. The stores and the Oxford Arms were torn down a few years ago and have since been replaced by a parking lot.

Boulder Spots

Naropa University, including the Jack Kerouac School of Disembodied Poetics (2130 Arapahoe Avenue, Boulder, 80302): Co-founded by Allen Ginsberg and Anne Waldman as disciples of university founder Chögyam Trungpa Rinpoche in 1974.

Beat Book Store (1200 Pearl Street, Boulder): Owned and operated by Naropa graduate Thomas Peters.

Central City

Central City Opera (124 Eureka Street, Central City): Kerouac and Cassady were invited here by Denver D. Doll (real name Justin W. Brierly) in *On the Road.*

Wheat Ridge

Mount Olivet Cemetery (12801 West 44th Avenue, Wheat Ridge, 80033): Where Neal Cassady Sr. is buried, along with his wife, Maude, and her former husband, James Daly.

INDEX

A

Adding Machine, The 106, 108, 114
Alarmclock, Henry 25, 26, 85, 114, 124, 127, 132

B

Baraka, Amiri (aka Leroi Jones) 15
Beat Generation 11, 15, 21, 22, 51, 54, 55, 67, 75, 86, 103, 109, 114, 122, 124, 125
Beats at Naropa 109
Big Sur 19, 28, 30
Boulder 15, 22, 87, 88, 106, 109, 112, 113, 116, 123
Brierly, Justin W. 36, 67, 68, 70, 72, 98
Buddhism 29, 42, 90, 109, 115, 124
Burroughs, William S. 11, 12, 13, 15, 16, 19, 24, 29, 38, 45, 65, 75, 78, 81, 87, 88, 89, 102, 106, 108, 109, 114

C

Carr, Lucien 19, 27, 108
Cassady, Carolyn 14, 19, 24, 30, 37, 52, 91, 117, 121
Cassady, Neal 16, 18, 21, 27, 29, 30, 32, 35, 37, 39, 41, 42, 44, 45, 49, 55, 59, 67, 68, 70, 75, 76, 77, 78, 81, 83, 86, 91, 94, 97, 98, 102, 117, 122, 123, 125
Cayce, Edgar 41, 42, 121
Charlie Brown's Bar & Grill 24, 52
Colburn Hotel 24, 36, 52
Colfax Avenue 21, 26, 39, 82, 86, 103, 117, 127
Corso, Gregory 11, 15, 16, 86, 109, 111, 114, 119
Cursed from Birth 86, 87, 88, 89

D

Dalton, Heather 91, 97, 103, 117, 120, 122
Demon Box 76

Index

Denver Botanic Gardens 47
Di Prima, Diane 14, 15

E

East High School 21, 39, 45, 67, 68, 96, 117
Ebert Elementary 39, 43
Elitch Gardens Theme Park 46, 47

F

First Third, The 18, 28, 29, 39
Five Points 31, 32, 46, 55, 57, 59, 60, 62, 102

G

Ginsberg, Allen 11, 12, 13, 15, 18, 19, 22, 29, 30, 35, 36, 38, 52, 54, 55, 57, 65, 66, 67, 68, 80, 81, 86, 89, 90, 91, 97, 102, 105, 106, 108, 109, 114, 115, 124

H

Heart Beat 19
Henderson, Lu Anne 36, 37, 49, 50, 51, 54, 59, 65, 91, 98, 102
Hinkle, Al 57, 64, 65, 68, 121
Holmes, John Clellon 11, 27, 34, 45, 64
Holy Ghost Catholic Church 39
Howl 22, 38, 115
Hyatt, Bob 96, 97, 98, 101, 120
Hyatt, Henry 100, 103, 104, 105

K

Kaufman, Bob 15
Kerouac, Jack 11, 12, 13, 16, 18, 19, 24, 27, 28, 29, 30, 32, 34, 35, 38, 41, 42, 43, 44, 47, 48, 49, 50, 54, 55, 57, 59, 60, 64, 65, 66, 67, 68, 72, 74, 75, 77, 80, 86, 91, 97, 98, 102, 108, 114, 123, 124
Kesey, Ken 26, 30, 75, 76, 78, 89
Kill Your Darlings 19
Krassner, Paul 16, 26

L

Lake, Larry 26, 80, 81, 82, 86, 89, 90
Lower Downtown Denver 28, 29, 31, 44, 46

M

Magic Trip, The 19
Merry Pranksters 19, 42, 49, 59, 75, 79, 125
My Brother's Bar 70, 86

N

Naked Lunch 19, 38, 81, 87
Nicosia, Gerald 37, 49, 50, 51, 59, 98
Notes of a Dirty Old Man 42

O

Off the Road 14, 37, 98
One and Only 49, 50, 51, 59, 65, 98
On the Road 12, 16, 18, 22, 27, 30, 32, 36, 38, 41, 44, 47, 48, 50, 52, 55, 64, 65, 66, 67, 68, 72, 77, 97, 101, 102

S

Sanders, Ed 109, 116, 125
Scibella, Tony 24, 26, 81, 82, 83, 86
Sonny Lawson Park 32
Source, The 81

INDEX

T

Thompson, Hunter S. 15

U

United States Post Office 39, 41
University of Denver 52

V

Visions of Cody 22, 27, 29, 30, 32, 33, 34, 38, 41, 44, 45, 60, 64, 65, 67, 68, 77

W

Waldman, Anne 14, 15, 24, 89, 106, 108, 109, 115
Ward, Edwin Forrest 21, 24, 25, 26, 80, 81, 82, 86, 88, 89, 90, 96, 98, 103
White, Ed 24, 47, 48, 49, 68, 80
"Write a Madder Letter if You Can" 48

Z

Za Za's 28

About the Author

Zack Kopp is a freelance writer and editor in Denver. He is the author of two novels, a short story collection, a book of poetry, a collection of metamorphic prose and, most recently, a collection of articles, essays, interviews, reviews and commentary called *Where's Kopp?*

His books are available at Amazon.
You can also find his frequently updated multi-genre blog at http://rentparty.blogspot.com.